BEACON HILL, BACK BAY

AND THE BUILDING OF

BOSTON'S
GOLDEN AGE

BEACON HILL, BACK BAY

AND THE BUILDING OF

BOSTON'S

GOLDEN AGE

TED CLARKE

THE
History
PRESS

Published by The History Press
Charleston, SC 29403
www.historypress.net

Front cover: View of the city of Boston from Dorchester Heights, 1841, Robert Havell. *Back cover:* Isabella Stewart Gardner, by John Singer Sargent, and Bates Hall in the Boston Public Library.

First published 2010

ISBN 978-1-5402-0426-4

Library of Congress Cataloging-in-Publication Data
Clarke, Theodore G.
Beacon Hill, Back Bay, and the building of Boston's golden age / Ted Clarke.
p. cm.
Includes bibliographical references and index.
ISBN 978-1-59629-161-4
1. Beacon Hill (Boston, Mass.)--History--19th century. 2. Back Bay (Boston, Mass.)--
History--19th century. 3. Boston (Mass.)--History--19th century. 4. Beacon Hill (Boston,
Mass.)--Biography. 5. Back Bay (Boston, Mass.)--Biography. 6. Boston (Mass.)--Biography.
I. Title.
F73.68.B4C53 2010
974.4'61--dc22
2010025319

CONTENTS

AUTHOR'S NOTE

This has been a lingering look at a Boston I've known and loved well. As a child, I walked the historic sites and shopped the downtown with my parents and came to understand that Boston was special. As a high school student, I worked part time and summers in Boston and got the "feel" of this interesting and growing city.

But as a college student, I came to know it intimately on my own, at my chosen pace and according to my own interests. I attended four-year college on the Fenway and enjoyed the institutions provided fatefully for me (or so I thought) within close or walking distance in this walking city. The Museum of Fine Arts and the Gardner Museum were near at hand and free or cheap in those days. Symphony Hall and the Boston Public Library were but a stretch of the leg away, as were the Public Garden, the South End and Beacon Hill, Charles Street and the Charles River.

I knew the buildings that arise in my story. I saw some of them—like Mechanics Hall—being demolished with the swing of a wrecking ball. This had been a place where I saw Ted Williams demonstrate fly-fishing at the Sportsman's Show and, speaking of Ted, saw at Fenway Park in Back Bay an otherwise hapless group of Red Sox fail miserably in pursuit of the Yankees in the late '50s on sunny spring days in the bleachers and watched as Ted, in his last appearance, drove the ball into those very bleachers a few rows below me as the bounce of that ball marked the end of an era.

So there's nostalgia here but also a knowledge of Boston culture that comes from being steeped in the city's traditions and watching its growth as I experienced my own. The years that I've known have been a run-up to

and a culmination of the city's second Golden Age. The world-class city that I've known has redefined itself after a period of blight and depression that followed the period told about in this book. Boston was able to rebuild and shake its shabbiness because it was built well in the first place. The planning, energy and culture that arose from it remained in place even during the dreary years and have been there to build upon as Boston looks forward to further growth and shining.

INTRODUCTION

After Boston had driven the British occupation force out of the town and out of the harbor in 1776, many of its citizen-soldiers went on to fight in the other colonies with Washington's often ragtag army until, at last, the underdog Americans brought the mighty army of the British Empire to its knees at Yorktown, Virginia, in October 1781. Americans, and especially Bostonians, felt empowered by their success in resisting the king and his minions and subsequently by their ability to stand on their own as a new nation. That independent, can-do spirit became part of the culture as Boston headed into a new century.

When the war was over, Boston maintained and improved its position as a major American city with 18,328 souls as of the 1790 census. But additionally, it became one of the world's busiest ports for international trade, and certainly one of its wealthiest. Its citizens wore an aura of confidence, having achieved so much. They renamed many major streets to reflect their "Americanization," dismissing such names as "King" and "Queen" in favor of "State" and "Court," and named their main street "Washington" for the man who had liberated their city and nation.

Like their Revolutionary War activist ancestors, the people of the 1800s stood not still. While they increased the wealth and standing of the city through their maritime interests, they also moved into the area of manufacturing. They overcame a postwar period of inflation and trade restrictions and soon began to prosper. They had great success following the Revolution by trading in traditional trends with wares like fish, salt, rum and tobacco. A man named Frederick Tudor showed Yankee ingenuity by

shipping ice to warm areas in the summertime. Though it took a while to make a profit, his company eventually shipped ice to southern ports and even to India. The ice was taken from several local ponds, including Fresh Pond in Cambridge and Spy Pond in Arlington.

But during the Napoleonic wars between England and France, American trade suffered. The retaliative embargoes of Jefferson and Madison led to a decline in trade and American shipping, and they remained becalmed during the first part of the War of 1812. While trade with Europe was risky, American skippers followed the Trade Winds southeast to Rio de Janeiro and then on to the West Coast, trading with tribes along the Columbia River in the Northwest for hides and lumber. They then crossed the Pacific to China, as we shall see in more detail later, opening up the China trade.

Boston became a changing place. The streets of the town yielded the scents of faraway places and, eventually, the bustle of shipbuilding and commerce. Not only did sights and sounds and scents change, but so did attitudes. A people who had accomplished as much as they had could not easily accept the views of their fathers about the predestination ordained by the Calvinist-based Congregationalism. They chose not to believe that their fate was out of their hands, and they paid less and less attention to those who would tell them so—like their Congregationalist ministers. Soon, that faith was almost totally confined to a few churches, and in its place stood various Unitarian churches that were more receptive to science and self-determination.So the face of religion changed, too, in the early years of the nineteenth century. But religion wasn't the only change.

The very way of life—the ways of making a living—changed too. In addition to merchants and ship owners, Boston had other "doers"— entrepreneurs with ideas and drive—and what they did was achieve diversity. The ruling class got into manufacturing, too, building factories that would, over time, excel in producing leather, textiles and machinery, products that would be consumed locally, nationally and overseas as well. Bostonians were exhibiting traits for which they had become known. These "Yankee traders" had the basic survivor skill of taking what they had and turning it into something greater. Born and bred like the Pilgrims of yore on the lyricized "stern and rockbound coast" where life could only be wrested from nature and its forbidding environment in a tough tussle, the ancestors of Pilgrims and Puritans wrested success in a sturdy New England way.

One thing these New England Yankees had and used was the water power so generously provided by that otherwise forbidding nature. Rivers spilled in networks around the city, not the least of them the Merrimack, which flowed

twenty-five miles to the northwest. That distance was a bit of a hike for the limited mobility of the Boston capitalists, so they went ahead and built the Middlesex Canal to link the Merrimack with the local rivers that had been placed at their disposal.

On the banks of the Merrimack, only those twenty-five miles distant, and especially in the new city of Lowell, mills had been built that could and would be captured and thrust into Boston's commerical maw. This "capture" by the sticky influence of Boston money extended farther north to the Nashua River in New Hampshire and to the milltowns of that state, especially Manchester.

However, while water power defined the growth of Massachusetts manufacturing in the first part of the 19th century, travel and shipping by water would give way to the rolling power of the railroads in a scant few years, as the area's growth mimicked that of England's Industrial Revolution of the same period.

Turnpikes followed in short order, including roads like the Worcester and Newburyport Turnpikes, which terminated in Boston. These roads still exist as Routes 9 and 1, as does the Salem-Lawrence Turnpike, which is now Route 114.

Those 18,328 souls mentioned earlier were fewer than needed to bolster and project the growth we're talking about here. Large populations went hand in hand with growth in those early days. The city's numbers grew, of course, as the country grew—slowly at first, but then exponentially. By 1820, the numbers had more than doubled to 43,000. That increased another third to 61,392 at the time of the 1840 census, but then it exploded.

In the middle of the 1840s, immigrants from famine-torn Ireland (and other countries) began to arrive by the thousands. Most of these had been hardscrabble farmers at home, and they hadn't the skills to make their way into the middle class in this new land. But they had strong bodies and a need to survive and prosper, just as the original settlers had done. So they provided the boost to the labor market that was needed in this "perfect storm" of a circumstance.

The growth of Boston, with its accompanying expansion of infrastructure and influence, gives us a chance to look at what happens to a growth area, changes commonly experienced in any such growth, but in a place— Boston—where we can recognize the changes and feel more intimate with the places and people involved in them.

As with most growth in power, prestige and wealth, a movement in culture and comforts came along, too, and this growth and the places that fostered it

remain today. The festooning of the arts, literature, medicine and education led to Boston being labeled the "Athens of America." It also brought on what, in my mind at least, was Boston's first "Golden Age." It was an exciting time, and I'm eager to tell you about it.

CHAPTER 1

THE BRAHMINS
OF BOSTON

B oston Brahmins are the first families of Boston, they who are descendants
of the English Protestants who founded it. The term was coined by
Oliver Wendell Holmes Sr., who adopted it from the Sanskrit. A Brahmin is
a member of the highest caste among the Hindus. Holmes's Brahmins were
not strictly religious but were equally powerful.

The Brahmins were influential in the arts, culture, science, politics, trade,
and education. The nature of the Brahmins is summarized in the doggerel
"Boston Toast" by Harvard alumnus John Collins Bossidy:

> *And this is good old Boston,*
> *The home of the bean and the cod,*
> *Where the Lowells talk only to Cabots,*
> *And the Cabots talk only to God.*

In Boston history, John Winthrop and many other Puritans arrived in
America on the *Arabella* and sister ships and came to Boston in 1630. No
Cabots or Lowells were aboard. They came later and, like all Brahmins, are
often associated with Beacon Hill, but that also came later, as we'll see in
the next chapter. The wealth of these families arose from shipping, but that
would change as the city would change.

When the British evacuated Boston and, subsequently, when the
Revolutionary War ended, the composition of Boston's population changed,
especially at the top. Many of the pre-Revolution merchants were wealthy
Tories, and they had left town with the British troops, many of them headed

for Nova Scotia, some to England itself. Their departure also left holes in the mercantile fabric. These people not only had wealth but also had held leadership positions in the town. Those holes would necessarily be filled by other Bostonians, who would in turn become the elite of the moneyed class.

An iconic symbol of the change in leadership was the new State House that was designed by Charles Bulfinch and built on the crest of Beacon Hill in 1798. The area around the State House and on the southern part of Beacon Hill would soon be developed to provide new houses for these merchants. They made their fortunes in shipping but would turn to other things before too long.

After the Revolution, Boston's seafaring ways resumed and would continue into the nineteenth century. Their trade was mostly with the West Indies, especially with the British possessions in the Caribbean Islands that supplied sugar, cocoa, tobacco and molasses. Boston's merchants traded cod, whale oil, lumber and molasses. Resumption of the trade that had slowed during the Revolution brought new money to the coffers of the merchants, money that could be invested in old and new businesses as well as new houses, as we shall see.

The ships of these merchants also sailed through the Straits of Magellan and up the west coast of South America and on to China, where they traded furs and lumber for silk, tea and porcelain. The China trade began in Boston, where the *Columbia* was sent to China with a load of ginseng and came back with a boatload of tea. After that, ships went to the Pacific Northwest to buy furs from the Indian tribes and then exchanged those in China for tea or silver, a trade that made the merchants mounds of money.

Shipbuilding prospered, too, on Boston's docks, and a new type of ship was being built. Troubles with Mediterranean pirates led President Washington to authorize the building of a navy of six frigates. Boston would be the location for the building and launching of one of them. The USS *Constitution*, a forty-four-gun ship, was built in 1797 in Edmund Hart's shipyard in the North End and went down the ways, setting sail on Columbus Day of that year. It had an additional Boston connection: its copper bottom plates, spikes and bolts were fashioned by Paul Revere. It set sail for the Mediterranean and won peace from Tripoli under Captain Edward Preble in 1805.

A navy was a new thing, and its formation had to be planned and learned a step at a time. For one thing, it needed leadership. President Washington offered the position of secretary of the navy to Thomas Handasyd Perkins, who would later enjoy the title of "Merchant Prince" in Boston. Perkins would have done well at that job, since he was a fantastic organizer and was held in high esteem, but he had to refuse the honor because he was too busy

trading with Rio and China and, in fact, was a man who owned more ships than the government did.

So the fabulous fortunes acquired by this group and the financial growth of the town depended on Boston's shipping fleet and trade with the West Indies, Europe, China and India.

This "Codfish Aristocracy" also had a strong religious bent. As we enter this period, we find it mired in the dregs of its Puritan-Calvinist traditions where people's destinies were believed to be pre-ordained. These doctrines left little to self-reliance. The "City on the Hill" that the first settlers visualized relied upon the Lord, while these new Bostonians relied more upon themselves—and succeeded more often than not.

> *They that go down to the sea in ships, that do business in great waters; These see the works of the LORD, and his wonders in the deep. For he commandeth, and raiseth the stormy wind, which lifteth up the waves thereof. They mount up to the heaven, they go down again to the depths: their soul is melted because of trouble. They reel to and fro, and stagger like a drunken man, and are at their wits' end. Then they cry unto the LORD in their trouble, and he bringeth them out of their distresses. He maketh the storm a calm, so that the waves thereof are still. Then are they glad because they be quiet; so he bringeth them unto their desired haven.*
> —*Psalms, 107:23–30, King James Version*

However, the Lord did not always still the waves made by storms or the storms made by politics. Use of the seas and of shipping could be a fickle and sometimes dangerous thing. After the war, the British had closed West Indies trade to American ships. Then a maritime depression in the early nineteenth century harmed trade and became one of the factors that led wealthy Bostonians to want to diversify and tap into other streams of income.

A new type of sailing ship was built in the East Boston shipyard of Donald McKay. It was long and sleek and carried clouds of sails. Thus the name *Flying Cloud* was given to the first of these "clipper ships." Others followed: *Glory of the Sea, Great Republic* and *Sovereign of the Sea*. Long and sleeek, these were some of the fastest sailing ships ever to float. They also had cavernous holds and could accommodate large cargoes to and from the West Coast and China. Their heyday was short, however, since steam power was the future for all kinds of transportation.

Among the merchants, the Perkins family were leaders. They were merchants before the Revolution, and a number of them had been Loyalists

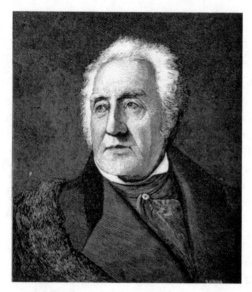

or Tories. During the Revolution, three members of the family fled the country and continued their political and business connections within the British Empire.

Thomas Handasyd Perkins, or T.H.P., was probably the best known of the family. As a boy, T.H.P. had listened to the reading of the Declaration of Independence from the balcony of the (Old) State House on State Street. After the Revolution, he remained in America and took advantage of his family's business connections, first in the trade with the West Indies, including the slave trade.

Thomas Handasyd Perkins, "Boston's merchant prince."

But that was not the extent of his success. For a while, the Perkins family were major players in the China trade. At first, that meant trading with the Indians along the Columbia River between today's Washington and Oregon in the northwestern United States for hides and furs. These were then taken to China and exchanged for tea, spices and porcelain, much desired by their fellow Brahmins back in Boston. They also made piles of money by lending it at high rates both in China and this country. But when the usual China trade fell off, they looked for something different.

One of those family members who had fled Boston was George Perkins, who became a merchant of the British Empire in Smyrna, Turkey. He made a connection with dealers who supplied Turkish opium. Through this connection, he, and his family in Boston, found a way around the monopoly on the opium trade to China that was held by the British East India Company. The Perkins family thus became opium traders.

T.H.P. later did other things that made people forget his darker deeds. He was among those who helped erect the Bunker Hill Monument and was a founder of the Granite Railway in Quincy, used to bring granite for the monument to the edge of the water to be shipped to Charlestown, where it was used for the monument.

He also donated his home in Boston for a school for the blind that became the Perkins School. He was a major benefactor for the school and also a

friend of Alexander Graham Bell, who invented the telephone in Boston. It was Perkins's money that bought out Bell's work. John Murray Forbes's son, William, scion of the family, became president of the American Bell Telephone Company and married the daughter of Ralph Waldo Emerson.

Russell Sturgis married T.H. Perkins's sister, Elizabeth, and joined the firm. His grandson, by the same name, moved to England and became chairman of the Baring Bank, the bank of the British East India Company. The China trade was financed almost entirely by the Baring Brothers Bank in England.

Retiring early, Perkins collected art from around the world and turned his home in Brookline into a veritable art museum, with landscape art on the grounds. When he died, the governor gave the state legislature the day off so that members could attend T.H.P.'s funeral.

The dynasty lived on. John Murray Forbes, a protégé and later partner of T.H. Perkins, earned millions in the China trade before turning, with T.H. Perkins, to railroads, the first of which was the above-mentioned Granite Railway. Captain Robert Bennett "Black Ben" Forbes, a seaworn commodore with strange traditions, built a house on Milton Hill that had portholes for windows and a secret treasure room hidden but connected to the cellar by a secret passage, one that was only discovered by family members seventy-five years after his death.

Boston's commercial progress was slowed again by "Mr. Madison's War," the War of 1812, which followed the stagnating Embargo of Jefferson and then the Non-Intercourse Act of Madison. All of this was quite unpopular in New England, where trade would be stifled. Merchant Nathaniel Appleton saw it this way: "This horrible madness has been perpetrated! We stand gaping at each other, hardly realizing that it can be true—then bursting into execrations of the madmen who have sacrificed us."

Once they stopped gaping at each other, however, Bostonians found their way around the restrictions and danger. For a while, ships were able to sail and enter other American ports without British interference for a bribe if they could prove they had been loaded before the war began.

The *Constitution* took part in the naval war and, under Isaac Hull, defeated the British frigate *Guerriere* off Nova Scotia. A sailor taking part in that battle saw British cannonballs bouncing off the sides of The *Constitution* and yelled out, "Huzza! Her sides are made of iron!" thus giving the ship the sobriquet by which it is commonly known. In fact, it was constructed of white oak and live oak and yellow resilient woods that repelled rot as well as cannonballs.

"Old Ironsides" also won a victory over HMS *Java* off the Massachusetts coast, but Captain James Lawrence and the *Chesapeake* suffered a crushing

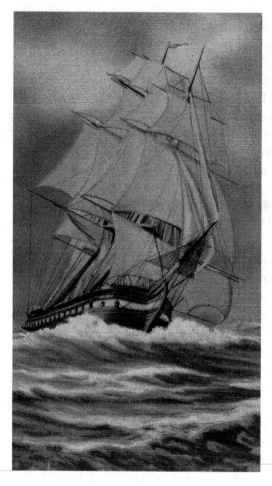

USS *Constitution.*

defeat to HMS *Shannon* in which he uttered the famous words, "Don't give up the ship!" as he went to his death. The smoke and sound of cannon fire could be seen and heard from Boston. The ship *was* given up, but his words endure as the motto of the U.S. Navy.

New England Federalists did more than grumble about the war, however. In 1814, the Massachusetts legislature called for a convention of the New England states in Hartford to protest the war and consider steps they might take. During the three-week Hartford Convention, the delegates debated whether to secede from the union or make a separate peace with Great Britain. Moderates won the day and decided to present President Madison with constitutional amendments, which would end the war and advance the mercantile interests of their region.

However, as the delegates got to Washington, D.C., they learned about Andrew Jackson's victory over the British at New Orleans and the Treaty of Ghent, which had concluded the war. This left the Federalists with egg on their faces and enabled their opponents to call them "The Party of Treason." It was essentially the end for the party of Adams and Hamilton as an influence on national politics.

This wasn't the only post–War of 1812 change. The wealthy merchants had begun to feel crowded in their North End and Fort Hill dwellings. Members of the working class were growing in numbers, and there was a desire to find a new neighborhood, one that would appeal to the Brahmins.

BEACON HILL

Home of the "Sifted Few"

The new wealth of the merchant class brought with it a need to spend some capital on homes for themselves. The wealthy had long lived in the North End or on Fort Hill, but these areas had become crowded with mechanics and those who worked in the shipping trades. They were no longer enclaves of the wealthy, and those people wanted a new enclave. The fortunes acquired by this group and the financial growth of the town depended on Boston's shipping fleet and trade with the West Indies, Europe, China and India.

Some storms are perfect—all the conditions come together at just the right moment and place. Beacon Hill was developed in this kind of way. It had been mostly pastureland at the time Washington became president, but things changed quickly after that. The West Boston Bridge to Cambridge from the northern end of Charles Street was built in 1792, six years after the Charles River Bridge to Charlestown. There was also the Warren Bridge. Those brought more traffic through the Beacon Hill area.

The north slope of the hill had already been settled to some extent and had wharves, ropewalks and boardinghouses for sailors and their activities, including types of entertainment that had earned the area the name of "Mount Whoredom."

The south slope was about to get some attention. The new state wanted government headquarters that would reflect its new status in federalism. The Town House (now the Old State House) had become cramped, and besides, it had been the seat of government for the royal governors, and something new was wanted. They bought the pastureland that had belonged to John

Hancock from his heirs and hired Charles Bulfinch to draw up plans for a new building. Its cornerstone was laid on the Fourth of July in 1795, and the "State House," as it would always be called, opened on January 11, 1798.

Next came some speculation. It came from Harrison Gray Otis, son of James Otis, fiery orator of Revolutionary fame and coiner of the phrase "No taxation without representation." Harrison himself was a member of the town committee that had bought the Hancock pasture, and no slouch, he had begun to think of the ramifications of having this fine Bulfinch building atop the hill along with all the government activities that would go along with it. He realized that the nearby land had become far more valuable because of this new building.

Beacon Hill was about to become a new and respected neighborhood. Only two things stood in the way: the land was too hilly for housing and most of it was already privately owned. The best part of it was 18.5 acres of upland farmland owned by the famed painter John Singleton Copley, who had left America during the Revolution and earned fame in London, where he'd been living for the past twenty years. There was also pastureland belonging to some others.

In 1795, a syndicate formed by Otis set to work. Called the Mount Vernon Proprietors, the group included founders Otis, Jonathan Mason, Joseph Woodward and Charles Ward Apthorp. Membership in the Proprietors changed frequently, but partners included Charles Bulfinch, Hepzibah Swan, Henry Jackson, Dr. Benjamin Joy and William Scollay. It was probably the first such syndicate in America and provided a model for future ones. These syndicate members were part of the aristocracy who had become wealthy trading codfish and other products in the West Indies and trading with South America and China.

They were smart people who realized that the population of Boston was growing and housing was needed, especially by wealthy people. This corporation decided to buy land and set up house lots and homes on the top of Beacon Hill, and to that end they purchased fifty acres on the south slope of the hill. This was the side that faced the common—and the sun. At the summit was the new State House, designed by architect Charles Bulfinch, the state office building that made the adjacent real estate potentially more valuable.

Among their purchases were those 18.5 acres from the estate of the famous portrait artist John Singleton Copley. He had been in London since the Revolution, ostensibly at the encouragement of Benjamin West, another American painter, but also to avoid becoming embroiled in the struggle.

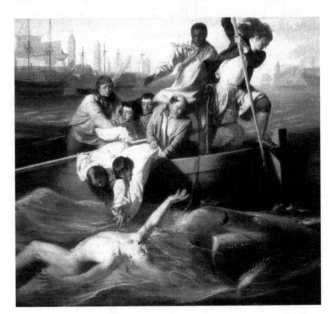

Above: The State
House, 1798.

Right: Copley's *Watson
and the Shark.*

Copley would become one of America's finest portrait painters and had skills
with painting of other kinds. The Museum of Fine Arts has an oustanding
collection of his work, including the famous one of Paul Revere examining
a piece of silverware. But one that attracts considerable attention is not a
portrait at all. It's a historical scene showing a man trying to swim for his
life to escape from a shark that is avidly pursuing him. It is called *Watson and*

the Shark, and the MFA owns one of three versions of it. (In the real attack, Watson lost his foot.)

But despite his artistic skills, Copley wasn't a sharp businessman, and in this case he appears to have been conned. He believed that his Beacon Hill land wasn't worth much, and he was glad to get rid of it, but he might have wondered why this wealthy group wanted it. For their part, they neglected to tell the London-based Copley that putting the State House atop the hill had made the area more valuable. His agents had made a poor real estate deal. When Copley finally reflected on it, he was unhappy. He sued, but without success. Otis was too good a lawyer.

This parcel of land in question ran from the present Beacon Street north to Pinckney—still the dividing barrier between the north and south slopes. It extended from just west of the State House at Walnut Street down Beacon to Charles, where the waters of Back Bay splashed ashore in those days.

The first thing the Proprietors did was to cut off the top sixty feet of Mout Vernon, the hill upon which the land was situated, in order to make it more suitable for house lots. The earth that was removed was taken by rail carts that ran on gravity downhill to Charles Street to be dumped. These operated so that gravity pulled the heavier loaded car downhill. Then, using pulleys, the lighter (empty) car was pulled up again by the next loaded car coming down.

Part of the motivation of this syndicate came from the Calvinist spirit that still remained to some extent among these Bostonians, even though their Congregationalist religion was, even then, being overshadowed by the more laissez faire and science-based Unitarianism. It would take some time before they would shed their notions of noblesse oblige, which made them believe it their duty to set a good example and provide help to those beneath their stature.

In this case, they would help the town by modeling appropriate behavior in setting up admirable housing. While they planned to live in their houses on that hill, they also wanted to draw similarly situated aristocrats to buy the neighboring lots and other handsome houses, thus enhancing their "city on a hill." Here's where Charles Bulfinch fit in.

Bulfinch was Boston's most noted architect. As a younger man, he had become educated during a "grand tour" of England and Europe, where he met with famous architects and learned from them and their work. That's how it was done in those times—no graduate programs, just learning from the "masters." From the time he returned to Boston in 1787, Bulfinch performed near miracles with the drab seaport. He transformed one of

the least attractive American cities into the most perfect one from an architectural point of view, and he did it with a prolific amount of work. In addition to the State House, it was he who designed many of Boston's most notable buildings and houses.

Charles Bulfinch had been born into a wealthy family and was Harvard educated, but the family had lost their money, and thus he had to work to support himself. That was Boston's good fortune, for he would design most of its best buildings and would serve in many positions, such as chief of police and chairman of selectmen. Anything he did, he did well, with fairness and class.

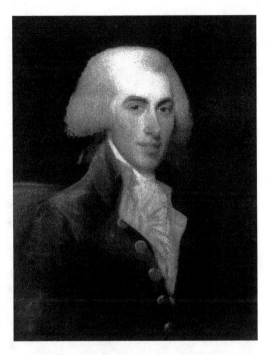

Charles Bulfinch.

Bulfinch laid out the streets and, along with other architects such as Asher Benjamin of western Massachusetts, designed the first homes. The lots would have room for gardens and stables and would be set back from the street a uniform thirty feet. This setback was not formalized in a contract or ordinance but was just a general agreement. Yet it was followed by subsequent builders right up to the late 1800s.

Bulfinch also planned a tree-lined garden square at the crest of the hill. It would be laid out with surrounding brick homes in the years between 1826 and 1840 and would be known as Louisburg Square. The proprietors wanted the center of this square to be empty of buildings. So it was, and so it is. It was eventually fenced in with wrought iron, and trees and grasses were planted. A fountain was added, and later, statues of Aristides and Columbus were placed at the two ends of the square.

We don't know how it got its name, but it's widely believed that it was named after the Battle of Louisburg, in which many New Englanders fought, including William Blackstone, whose freshwater spring—the one that made his Shawmut Peninsula habitable—was located on this site, it is

Louisburg Square.

Oliver Wendell Holmes Sr., "the autocrat of the breakfast table."

believed. Louisa May Alcott lived in the square, as did the mayor of Boston, Frederick Lincoln, and William Dean Howells, editor of *The Atlantic.* Scenes from a movie based on Thackeray's *Vanity Fair* were also filmed there.

The south slope of the hill attracted many wealthy people who became known as Beacon Hill Brahmins. But in Boston, these were not the Hindu upper caste. They were an untitled aristocracy who lived in Bulfinch-style houses on Beacon Hill. They gathered portraits of themselves, art and curios from Europe and China, embraced the newly popular Unitarian faith and clung to ideas of exclusivity. They were the people who ran the city, published its newspapers and magazines, owned the businesses and set the living standards.

Dr. Oliver Wendell Holmes Sr., who first used the term, also wrote verses in which he referred to Beacon as "the sunny street that holds the sifted few." In addition to Beacon Street, the "sifted" members of society also dwelled upon Mount Vernon and Chestnut Streets. Holmes lived on

Beacon Hill

Beacon Street, as did Colonel David Sears and Nathaniel Appleton the textile king. Senator Henry Cabot Lodge lived on Mount Vernon, as did Colonel Thomas Handasyd Perkins. Hepzibah Swan, who was the only woman among the original Proprietors, built three adjacent houses for her three daughters. On the same street, sea captain Charles Codman adorned the entrance of his house with two white marble urns that once stood in front of the chateau of the Empress Josephine, wife of Napoleon.

Holmes may have been fond of giving names to things, but his own name is given to the "Long Path" that runs across Boston Common from Beacon Street to Boylston. It was while walking near Beacon Street that Holmes proposed to his future wife, Amanda Lee Jackson. As they promenaded on the Beacon Street Mall, he asked her, "Will you take the long path with me? Think before you answer. If you take the long path with me now, I shall interpret it that we are to part no more." She thought before answering, "I will take the long path with you." And they did. As a result it is now the Oliver Wendell Holmes Sr. Walk.

In those days, Beacon Hill was essentially John Winthrop's "city on the hill" and was the place to be. In 1824, the Marquis de Lafayette, friend of Washington and of America during the Revolution, made a final tour of America and was invited to lay the cornerstone for the Bunker Hill Monument. Lafayette had a decidedly Boston connection in that T.H. Perkins had been instrumental in smuggling the son of the Marquis out of France during the Age of Terror when aristocrats were in mortal danger.

Lafayette was entertained on Beacon Hill at the home of Harrison Gray Otis (one of three homes designed for him by Bulfinch, two of them on the south slope). When Otis became mayor of Boston, which had newly been made a city (1822), he celebrated that event at his home at 42 Mount Vernon Street, which still stands.

Gray later entertained President James Monroe in 1817, and while Monroe was there, Bulfinch, as chairman of the selectmen, gave him a tour of the city. Monroe admired several of the buildings, and each time he asked who had designed the building, Bulfinch could truthfully say that *he* had. As a result, Monroe gave him the job of designing and completing the U.S. Capitol. Gray later hosted Henry Clay, who was secretary of state during the administration of John Quincy Adams.

At nearby 32 Mount Vernon lived Dr. Samuel Gridley Howe of the Perkins Institute (whose benefactor was the merchant prince Thomas Handasyd Perkins). His wife was Julia Ward Howe, who later wrote the words to "The Battle Hymn of the Republic," which became a theme of the Northern

armies during the Civil War. They entertained yet another president, Ulysses S. Grant. At 19 Louisburg Square, Mayor Lincoln honored the Prince of Wales, who would become King Edward VII of England. Writer Charles Dickens was also entertained on the Hill.

Beacon Hill had once been known as Trimountain with three connected peaks: Mount Vernon, Beacon and Cotton or Pemberton Hill. As we have seen, the top of Mount Vernon was carted down to Charles Street early in the century; Beacon Hill had been used to fill the millpond in the North Cove, where Bulfinch laid out the streets in what is today known as the "Bulfinch Triangle."

Only Pemberton remained as a high hill, and it, too, was leveled in 1835. Patrick T. Jackson, one of the founders of the mills at Lowell, had bought the

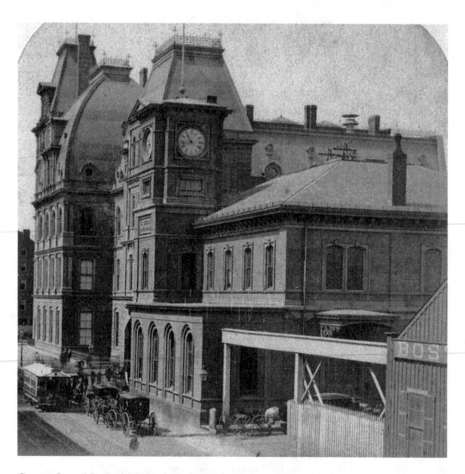

Greater Lowell Railroad Station, near today's North Station.

acreage and planned to shave it off as fill for new land north of Causeway Street where the railroads came in from the north. He would build a station there for the Boston and Lowell, and later it would be the site of North Station and the old Boston Garden.

Jackson hired a farmer, Asa Sheldon, who had helped him with the Boston & Lowell Railroad, to take seventy feet off the hill for the filling. Sheldon used 199 immigrant Irish, 60 Yankees and twenty-six oxen to do the job for twenty-eight cents an acre in five months. Sheldon then laid out Lowell, Nashua, Haverhill, Andover and Billerica Streets. The flattened area atop the hill became Pemberton Square. Today, the Suffolk County Courthouse stands there.

As the nineteenth century grew older, however, life on parts of Beacon Hill lost some of its luster. Other parts of town would earn more cachet, and some of the wealthy aristocrats and nouveau riche moved away from Beacon Hill.

A significant part of Boston's rapid population growth in the middle of the nineteenth century was due to the number of immigrants, mainly Irish. Throughout the nineteenth century, Boston became known as a haven for Irish immigrants, especially following the potato famine of 1845–49. Even to the present day, the largest percentage of people of Irish descent in the United States live in Boston. To our Beacon Hill Brahmins, the Irish were an underclass. The Brahmins were not only of English descent but were Protestants, too, whereas the Irish, oppressed in Great Britain by the English, were mainly Catholics.

It was common during the nineteenth century and into the next one to see "NINA" signs (for No Irish Need Apply). It didn't matter. The numbers of Irish continued to grow, and eventually, through their use of politics, the immigrant Irish gained the upper hand. Boston, once known as a WASP-Puritan stronghold, became thoroughly connected with the Irish.

As Boston's population continued to grow, there just weren't any places to build more homes, so the city added land and built upon that. After twenty years of filling in the South Cove, the South End was created. A large number of brownstones were built there, many of which survive.

Next in line would be Back Bay. A plan for its development came in 1857. Many of the wealthiest Bostonians wanted to invest in lots, provided they could get a price that would allow them to make a good profit. They argued to the Proprietors that they were risking their capital and deserved a good return on it, and they finally got their way. Once they were "in," the rest of the public followed, and the lots quickly sold out and proved to be good

investments. As soon as land was filled in, wide streets were laid out, lots were developed and more brownstones were built.

As real estate values fell on Beacon Hill, many of the older-style homes shared space with retail stores, some of them on the first floors with houses above. By 1875, homes in the Back Bay, with their modern conveniences, had outstripped Beacon Hill as the most desirable part of Boston.

The *north* slope of the hill, however, was a world apart from the area you have just read about…more on that later.

FROM TRADE TO TEXTILES

Where Cabots speak only to Lowells
And Lowells speak only to God.

It was Boston Brahmin Francis Cabot Lowell, a man who spoke to others in addition (we presume) to God, who would take Boston and New England in a new direction. Francis was born in Newburyport, brought up in Boston and attended Roxbury Latin and then Harvard, where he graduated in 1793. He married Hannah Jackson, with whom he had four children.

When Boston's merchants, sometimes called the Codfish Aristocracy, found their profits lagging because of Jefferson's Embargo Act and the War of 1812 that followed, they shifted seamlessly to another vehicle of growth—industry. Lowell played a big part in that; in fact, he was a guiding light.

A successful merchant, Lowell had traveled in 1810 to England and Scotland, where he learned about the Lancashire power looms and how they operated. Then he and a master mechanic named Paul Moody made an improved type of loom that could also spin and weave. In 1813, he founded the Boston Manufacturing Company with his brother-in-law Patrick Jackson and Nathaniel Appleton. The next year, they built a cotton mill in Waltham, Massachusetts. This system would not limit itself to Waltham. It would spread to Lowell, Lawrence, Fall River and eventually throughout the United States. This was really the birth of America's Industrial Revolution. *Life* magazine has called it one of the most significant events in the history of the United States, and *Fortune* magazine named Francis Cabot Lowell to its Hall of Fame.

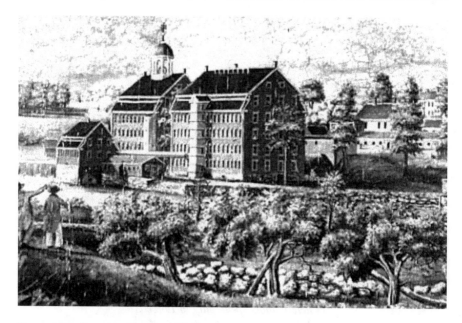

Boston Manufacturing Company, Waltham.

What happened in these places was different and better than what happened two decades before in Pawtucket, Rhode Island, where in 1793 Samuel Slater set up his mill using water power and industrial designs he had "stolen" from England by memorizing machinery and plants. That was the first successful spinning mill in America, and it processed cotton fiber into yarn and then sent the yarn out to small weaving shops and homes, where it was woven into cotton cloth on hand-run looms. This process had many small-time copycats, and by 1810, they could be found in many parts of New England.

Francis Cabot Lowell was likewise an idea thief. When he visited those textile mills in Lancashire, England, in 1810, he concentrated his mind on the workings of a power loom—an invention unknown in America up until then but one that would be needed if the textile indistry were to prosper on this side of the ocean. The British knew this and would not allow these machines to be exported. In fact, the plans for such a machine would have been considered contraband if Lowell had smuggled them out of the country. So he used another plan. He passed himself off as a country bumpkin and committed the plans to memory, just as Slater had done with earlier technology.

They were filling a need of their own, of course, but also the need of the people of Massachusetts for goods. Americans, especially those who lived

From Trade to Textiles

away from the coast, had a pent-up demand for manufactured goods. They had come to depend upon receiving these from England and other European countries, but now, because of hostilities and the stopping of trade, they couldn't get them.

We know that "Yankees," as New Englanders were called, had learned to depend on themselves. Self-reliance had become part of their culture. It came from having settled on a barren, friendless shore. Their ancestors lacked all the conveniences of city living and had to figure out survival for themselves. In fact, self-suifficiency was worn like a badge of honor among those folks who lived in the northeastern corner of the new nation. So when they couldn't import the goods that they needed, they just made their own. Mostly they had made them at home or in small workshops. But that no longer did the trick. It wasn't nearly enough, and making things in this way certainly wasn't fast enough to take care of everyone who needed them.

During the War of 1812, factories were thrown up along rivers, and they sold cotton goods around the country, expanding during the years of the war. By the end of the war, New England had more than 100,000 spindles. And more and better were soon to come.

Shortages were one spur to new manufacturing, but there was another, less obvious perhaps to every man, but just as compelling to Americans with vision. That vision came into focus as a result of the war. America *needed* its own factories because it couldn't depend on Britain, especially during periods of hostility, and certainly not for defense. Like twenty-first-century Americans with their dependence on foreign oil, our ancestors had become far too dependent for essential goods on nations that were often hostile to us.

Enter Lowell and associates. Here was a market ready for new entrepreneurs, and the Boston merchant class were certainly that. Soon they would provide many of the desired goods on a wider scale, cheaper and faster than New Englnders had been able to get them at any time before.

At this time, a new welthy class arose from an amalgam through marriage of Bostonians enriched by seafaring merging with families who were becoming the industrial elite. They intermarried, lived near one another and, in one significant case, entered a common enterprise. A group of about forty Boston families became known as the "Boston Associates." They would at length expand their investments into real estate, banking and railroads like the Boston & Albany, Boston & Maine and Boston and Lowell.

The Boston Associates, under the leadership of Francis Cabot Lowell, built a cotton mill in Waltham, which was the first modern factory in the United States. It was also the first time that all the processes for making

cloth from cotton had taken place under one roof while using power looms. His accomplishment, and those of his colleagues and partners, jump-started American industry, pushing it out of the small shops and cottage industries and into a modern factory system.

While the first mill was built on the Charles at Waltham, that would be but the beginning of a new system that would move north to the Merrimack Valley and then throughout New England and on to other parts of America. The Boston Associates were starting the Industrial Revolution in America. They would become richer, and America would elevate itself to stand among the world's first-rate nations.

Nathaniel Appleton, another Beacon Hill Brahmin, had met his distant cousin Lowell while both were in Scotland, and together they talked about mills and looms and factories and went to look at all these things together. While they were in Britain earlier, Nathaniel as well as Lowell had formed strong negative opinions about the human toll taken by conditions in English factories—opinions that would have an impact later as they decided how to run their own factories.

The Boston Manufacturing Company—whose other partner, Patrick T. Jackson, Lowell's brother-in-law, contributed capital—set up business in September 1813. They chose the site they did in Waltham along the Charles River because that was where the river had a ten-foot drop and could supply water power to run their looms. There was lots of power there, they thought; probably enough to run all the mills they wanted for years and years and years—or maybe not that many years.

They hired a skilled mechanical craftsman named Paul Moody from Byfield to build the machinery and supervise the building of the mill. They chose well. Moody was a mechanical genius. The power loom that he was able to build within a year would be revolutionary in American industry, and the mill that Moody built would also allow all the steps in the production of cotton cloth to happen in just one building. (Moody was later honored by having streets in Waltham and Lowell named for him.)

But Moody wasn't through with innovation yet. He would also replace the shaft and gear system that had been used everywhere to transmit power. It was difficult to get precisely machined gears, so American mills were rough and noisy with lots of crude vibrations, and they had to be run at slow speeds, which was counterproductive. The textile industry was just then in its infancy, but creative people with drive were about to smooth things out.

Moody's answer to this outmoded system was a simpler and more efficient one that used belts and pulleys. These were powered by water turbines.

From Trade to Textiles

Then, by the end of 1814, Jacob Perkins had installed the first dam, sluice, water wheel, flumes and raceway. Progress was coming in small steps, but it was inexorable.

But for all this effort and inspired achievement, the cloth did not sell. What good was progress to a capitalist if he couldn't make money from it? It was time for more creativity of a different kind. It was time to promote the product. It was time for Nathaniel Appleton to step in.

Nathaniel had been through those English factories with his cousin and understood what was at stake. But unlike his technologically talented cousin, Nathaniel was a solid businessman. He would figure out how to move lots of product. And best of all, he was already on board. Appleton had contributed $10,000 to formation of the company and had been selected for its board of directors.

It was Appleton who now set out to establish systems that would market and distribute fabrics in a way that would match the manufacturing plan they had just established. He developed an early form of market research to help him predict what products were likely to sell, and this let him advise mill owners— even mills that were not his own. He didn't consider them rivals, because all the Waltham mills belonged to a few families who were joined in marriage or were neighbors on Beacon Hill. Their industrial and financial concerns were all of a piece. It was kind of an aristocratic and capitalistic oligarchy.

These leaders provided the schools, housing and churches that their employees would use, as well as things the mills needed like machinery, raw materials, banking and insurance and railroads. Cooperation in these enterprises gave them economy of scale and reduced competition, giving them essentially a near-monopoly in the textile sector.

Nathaniel Appleton, who had been a merchant with his brother, William, knew that the only emporium for selling cloth in Boston was on Cornhill Street, a curving street that ran from School Street to State Street, not far from the Old State House and also quite close to the market at Dock Square. There, Isaac Bowers and his wife kept a shop selling domestically produced goods. Appleton went to see Mrs. Bowers with some of the cloth. After a while she reported to him, "Everybody praised the goods and had no objection to the price. They just wouldn't buy American-made cotton sheets even though it was thirty-seven inches wide instead of a yard like the goods from India, which it was supposed to imitate."

The front door having been closed, Appleton scouted around for a different entrance. He suggested that some goods be sent to a new firm in which he was a partner and that the price be set at a low twenty-five cents a yard.

The goods were auctioned off at thirty cents a yard, with Nathaniel getting a 1 percent commission, and soon Appleton's price became the established price, underselling imported goods. His sales amounted to millions of dollars. American textiles were on their way to the top of the world market.

Having brought technical innovation to their mills, and then having accomplished market dominance, the Boston Associates sold more and more cloth at ever cheaper prices and accumulated a huge amount of wealth. At the same time, they treated their help well. Appleton and his colleagues "spread the wealth" by providing jobs, incomes and good working conditions for their employees, turning around the conditions they had seen in England.

Appleton, for one, felt a bit uncomfortable with the degree to which he had personally profited from his skills and didn't want to be regarded as someone who was just in it for the money. That meant that Nathaniel had a *conscience*, even though he was later regarded as a *cotton* Whig and not a *conscience* Whig. In 1839, he married Harriet Coffin Sumner, cousin of abolitionist Charles Sumner, who would make a famous speech about the "unhallowed union" between "the lords of the lash and the lords of the loom." People like Nathaniel Appleton were branded as "cotton" as opposed to "conscience" Whigs. Appleton, on the other hand, considered this unfair. Such philosophical disagreements have not disappeared; they're just wrapped now in different clothing.

Appleton believed (or perhaps rationalized) that slavery would gradually die out but thought that abolitionists had only made southerners band together more strongly and had simply delayed emancipation. He was a gradualist. We still have them. We also have those who want (need) change to be immediate. Times change; people don't.

By early in 1815, the cotton goods being manufactured at the Waltham mill were being sold, and production had to be expanded to keep up with demand. A second mill was being built next to and bigger than the first. (In years to come, the two mills would be connected.) The companies produced coarse cloth to be used domestically, especially for servants and workers. When a third mill was built, all the power the Charles could generate was being used.

The system they developed depended on Lowell's technical understanding and Appleton's business prowess, but both men shared another vision as well. In addition to the process and the machinery, Appleton and Lowell had taken away from England strong impressions of the harsh conditions within the factories and had privately vowed to improve on that situation in their own mills. They set up a different kind of factory system that took an interest in their workers.

From Trade to Textiles

Rather than using child labor, the Boston Associates brought in young women from the farm families of northern New England to come to Waltham and run the machinery. Most of these women only worked for a few months or years, often until they got married. They were called "mill girls," and they lived in boardinghouses provided by the company where older women supervised them, enforcing discipline and the moral code of the day. The company expected them to reflect "the moral purity which has ever been a characteristic of our beloved New England," as Appleton put it. The company also provided schools, churches, stores and banks and required the workers to attend church (of any denomination). Those who did not live up to moral expectations were fired.

More than any of his associates, Appleton was concerned with the moral and social effects of manufacturing. He hoped that paternalistic management, combined with wages well above subsistence level, would prevent the development of a degraded working class who owned no property.

The life of these girls was not easy, but it was better than what they had been used to. They were awakened at 4:40 a.m., reported to work at 5:00, had breakfast at 7:00, had a forty-five-minute break for lunch and worked until 7:00 in the evening, when the factory closed and the girls went back to their boardinghouses. This was a six-day-a-week routine, and it was known as the "Waltham System."

Although these young women were paid lower wages than men would have received, they did get other benefits of a non-financial type. They were able to have educational opportunities they could get nowhere else and also were offered religious freedoms. They were paid in cash that went into their own pockets, not to a parent, spouse or company store, and the houses in which they lived were clean and of a high quality. Although it may not have occurred to them at the time, they were a significant and new part of the Industrial Revolution in America.

This "humane" bent of Lowell and Appleton seems minimal to readers of later generations, but it was far from accepted practice for its day, as attested to by Charles Dickens, who knew about such things and would visit their factories. They also had an interest in utopian experiments like those of Robert Owen in Lanark, Scotland, and others closer to home. These ideas complied with the sense of noblesse oblige that was found in the upper classes.

Appleton was an optimist. He believed that men of goodwill would show their goodwill by showing kindness to those in their employ, and this was reflected in the treatment of workers in the mills.

Either because of or in spite of these ameliorations of working conditions, the mills succeeded, but like most businesses, continued success would not

allow holding onto the same methods year after year. Staying put would have meant falling behind, and we have already seen that the Boston Associates were not afraid to try new things.

In the case of Waltham, making changes became an obvious need. By the early years of the next decade, the water power at the Waltham point of the Charles River had been maxed out, and the company wanted to expand. So they needed more power and would have to go somewhere else to set up shop. That would be in a new city not far northwest of Waltham. It would, in time, be called "Lowell" after Francis Cabot Lowell.

The site of the Waltham mill was declared a National Historic Landmark and is today occupied by the Charles River Museum of Industry. The original loom was lost in a fire, but a version of it was reconstructed by a computer program. Visitors can watch it make cloth.

In 1822 (the same year Boston became a city), the Merrimack Manufacturing Company was incorporated under the same group of investors. Later, they would set up mills in Lawrence, Massachusetts, Manchester, New Hampshire, and other locations around New England, using the systems introduced at Waltham.

In a pamphlet entitled *The Origin of Lowell*, Appleton wrote of the mills: "The contrast in the character of our manufacturing population with that of Europe has been the admiration of most intelligent strangers. The effect has been to more than double the wages of that description of labor from what they were before the introduction of this manufacture."

Appleton purchased the water power at Pawtucket Falls in East Chelmsford on the Merrimack, and he was one of the founders of the Merrimac Manufacturing Company. Pawtucket is an Algonkian word meaning "at the falls."

The existence of these falls as a barrier to travel along the river necessitated the construction of the Pawtucket Canal in the last decade of the eighteenth century. In the 1820s, the falls, the canal and the hydropower they provided led to the choosing of this site as America's first planned factory town, Lowell. Over the next thirty years, hydropower from the falls exclusively ran Lowell's numerous textile factories via the city's canal system.

The first canal, the Pawtucket Canal, was built at the Merrimack's junction with the Concord River by entrepreneurs from Newburyport. That was a town at the mouth of the river at the Atlantic, and it had become a shipping port for timber. It would be easier to get the timber to the mouth of the river if they had a way around the falls. So in 1796, the "Proprietors of Locks and Canals on Merrimack Riveer" built the one-and-a-half-mile-long Pawtucket Canal.

From Trade to Textiles

In 1803, another canal was completed, this the Middlesex Canal, which connected the Merrimack with the Mystic River at the port of Boston. It was twenty-seven miles in length and had twenty locks and seven aqueducts. It connected Boston's network of rivers and streams with the Merrimack's. Ironically, this canal later carried crossties that would be used to build the Boston & Lowell Railroad, whose existence would make the canal nearly passé when it was finished in 1835.

The Boston Associates helped develop this railroad and other railroad lines in New England. They owned controlling stock in a host of Boston financial institutions, allowing them to finance and insure ventures through their own companies. Until the Civil War, the Boston Associates were New England's dominant capitalists.

Lowell also had a system of power canals. These operated on two levels, turning the water wheels of forty-one mills, powering 320,000 spindles and close to ten thousand looms—power that provided jobs for about ten thousand workers.

To make the canals more efficient, a dam was begun at the top of the falls in the 1820s and was enlarged into the 1840s. The final structure, which exists in the same form today, is a stone dam that can channel the entire river into the canal system.

Charles Dickens visited Lowell in the winter of 1842. His contemporary impressions are of value to history, especially since the pages of his fiction are filled with examples of depressing treatment of the lower classes in England. He recorded his thoughts on the Lowell visit in the fourth chapter of his *American Notes*.

Dickens wrote that he had examined several of the factories, "in every part; and saw them in their ordinary working aspect, with no preparation of any kind, or departure from their ordinary every-day proceedings"; that the girls "were all well dressed: and that phrase necessarily includes extreme cleanliness. They had serviceable bonnets, good warm cloaks, and shawls. Moreover, there were places in the mill in which they could deposit these things without injury; and there were conveniences for washing. They were healthy in appearance, many of them remarkably so, and had the manners and deportment of young women; not of degraded brutes of burden."

He spoke of their work environment: "The rooms in which they worked were as well ordered as themselves. In the windows of some there were green plants, which were trained to shade the glass; in all, there was as much fresh air, cleanliness, and comfort as the nature of the occupation would possibly admit of." Again: "They reside in various boarding-houses near at hand.

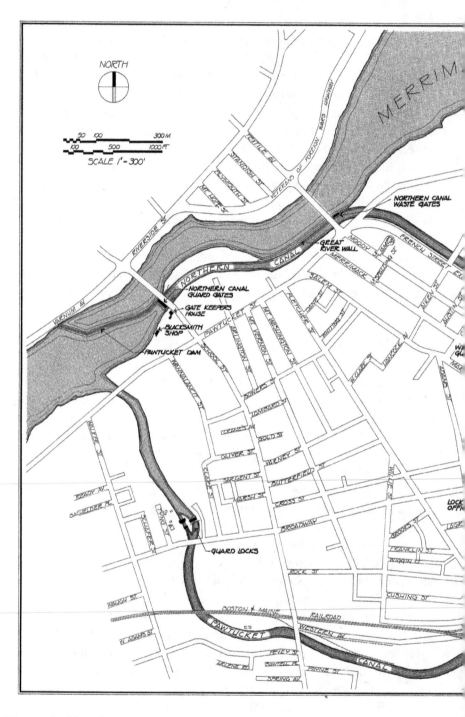

The canals of Lowell.

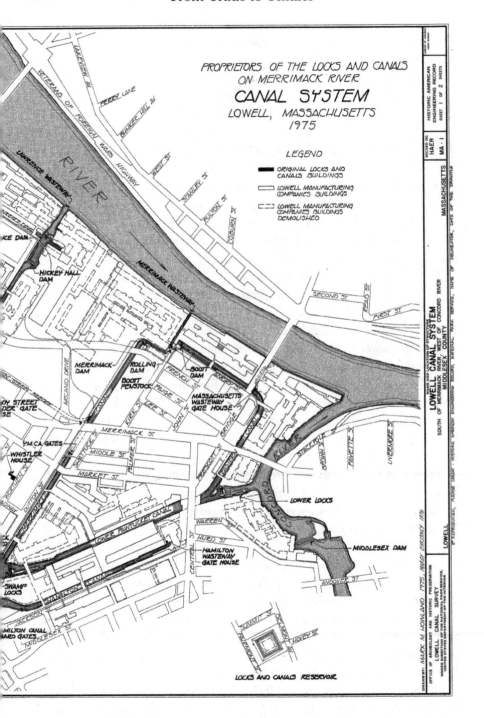

The owners of the mills are particularly careful to allow no persons to enter upon the possession of these houses, whose characters have not undergone the most searching and thorough enquiry."

Then he offered some details to bring the situation home to his readers: "Firstly, there is a joint-stock piano in a great many of the boarding-houses. Secondly, nearly all these young ladies subscribe to circulating libraries. Thirdly, they have got up among themselves a periodical called 'The Lowell Offering' whereof I brought away from Lowell four hundred good solid pages, which I have read from beginning to end." And: "Of the merits of the 'Lowell Offering' as a literary production, I will only observe, putting entirely out of sight the fact of the articles having been written by these girls after the arduous labors of the day, that it will compare advantageously with a great many English Annuals."

The selection of the site for "Lowell" was based, of course, on water power. North and west of the present downtown, and near the Lowell National Historic Park, roar the powerful Pawtucket Falls in the Merrimack River. Lowell became the location of America's first planned factory town. The water power ran the mills in several factories over the next few decades and used a system of canals for transportation as well as power.

As English entrepreneurs had done before them, the Boston Associates branched out into corollary enterprises as well. They helped to develop railroads such as the Boston and Lowell. They raised money for expansion by selling shares in the company for $1,000 each, using a shareholding model that is still used.

They also buttressed their holdings by controlling much of the stock in Boston banks and financial institutions. That gave them venture capital for further investment. They also got into government by becoming active in the Whig Party in their state.

Nathaniel Appleton, however, was not happy with how his mills turned out in later years. In the 1850s, the market for textiles became saturated; the original owners had sold out or died off, and the new people often strayed from the standards Appleton and Lowell had set down. He criticized them for worrying more about the stockholders than about keeping up the mills and paying their workers a living wage and treating them well. He did not understand why the new workforce of permanent mill hands lacked the zeal for self-improvement of the early "factory girls."

Closer to home on Beacon Hill, Nathaniel also could not understand the appeal of abolitionism for the younger members of his own Whig Party, as well as for his daughter, Fanny, and her husband, Henry Wadsworth Longfellow.

THE NORTH SLOPE

Where the Grapes of Wrath Were Stored

The so-called "north slope" of Beacon Hill had a history vastly different from that of the south, but despite the barriers between them these neighborhoods were oddly connected by some of the people who lived there during the nineteenth century—people who contributed to this Golden Age of Boston.

In the early days of the nineteenth century, the area of Myrtle, Southac (Phillips) and Belknap (Joy) Streets and down the slope to Cambridge Street toward the waterfront remained isolated from the development of the Mount Vernon Proprietors. Its streets had not been laid out as carefully, and they were covered with shacks, rather than brownstones, even though parts of the area were the oldest on the hill.

Early in the nineteenth century, a rope-making industry stretched out along Myrtle Street, where workers walked backward, twisting threads of hemp into ropes. They were called "ropewalks" because of this backward-walking procedure used at that time. The twisted rope was then covered with pungent hot pitch to preserve the fibers.

Because of the closeness to the waterfront and the low rents, it was a transitional section with many sailors and laborers staying in it for a time. It also had a history of disorderly conduct, and so it bore the name "Mount Whoredom" or "The Combat Zone," and it continued to be an area of disorder and complaint, used for recreation at various times by Spanish sailors and those from the USS *Constitution*.

A report to the Boston Female Society in 1817 by Reverend James Davis called it "the place where Satan's seat is" and "a sink of sin." He noted

such activities as gambling, fighting, blaspheming, drinking and carousing and said the area housed three hundred females "wholly devoid of shame and modesty."

Upon his election, Mayor Josiah Quincy vowed to clean up the area and build a house of correction there. He was told he could not do it without a military force, but he did, using some tough young men instead.

The north slope also housed much of Boston's black population, many of them living halfway down the hill toward Cambridge Street. They served as barbers, waiters, musicians, laundresses and sailors. They would also claim the city's attention as a debate began to rage over slavery.

The population of blacks in Boston was about fifteen thousand. They had settled first in the North End, but by the middle of the nineteenth century about four out of five lived on the north slope, starting at Joy Street and spreading as far west as Charles Street, or to the nearby West End. Many of them worked nearby. Some served as domestics in homes on the south slope. A few would become heroes and legends in Boston and farther afield, while others would overcome an indigent youth and rise to uncommon accomplishments.

Set apart by geography, but nonetheless close at hand, supporters of this black community lived on the south slope. Many of them were abolitionists, the chief among them William Lloyd Garrison, who really began the movement with his first issue of *The Liberator* in 1831. Slavery had been illegal in Massachusetts since 1783, when Chief Justice William Cushing had declared it to be inconsistent with the state's new constitution. Abolitionists like Garrison wanted it ended everywhere, and they wanted that *now.*

Like others everywhere, those whose views and pronouncements differed radically from the mainstream were considered "over the top." In this struggle, Garrison was so viewed by most people because his views left no room for compromise. Slavery was evil, and he wanted everyone to know it and work to eradicate it. To him, slaveholders had no rights over other humans, and he wanted the repulsive practice stopped at once. Not so with other antislavery people who were gradualists. They believed their goals could be reached by legal, peaceful means. That didn't mean Garrison was alone. Others felt as he did, and one of the most powerful voices was an escaped slave, Frederick Douglass, who was a frequent and compelling speaker who later wrote eloquently as editor of the weekly newspaper *Northern Star.*

A series of cultural movements culminated in making Boston, and particularly Beacon Hill, the focal point of abolitionism in America. This was a surprising change from the thoughts and activities with which the area

had always been associated. But, then again, it wasn't so much of a departure after all, since it ran parallel with those religious changes we've noted that marked post-Revolution Boston. Though Puritan instincts died hard, religion *had* changed. Modern Bostonians did not spend whole days in church. Some rarely went at all, and some churches had a hard time keeping their doors open. For example, Congregationalism had nearly died out, and in its place stood the newer, less hide-bound Unitarianism, a liberal system that valued reason, science and free will and didn't believe that people

William Lloyd Garrison.

were born either pure or depraved. Its adherents often looked for good causes, as did the currently popular Transcendentalism. They would find one in nineteenth-century Boston, and they would find it close to home. That cause was antislavery, and it would evolve for many Beacon Hillers and Bostonians into abolitionism.

The plight of the nearby black community and of slaves in the South became that cause. The intensity of the reform movement grew with successive events and reached a zenith with the struggle over runaway slaves, a cause that appealed to an ever-rising number of Bostonians.

Like many such movements, it would take time and events to shift public opinion and it would take pain, suffering and courage. The long struggle for the hearts and minds of Boston's whites is analogous to dragging the population of the south slope up the hill and over the top to join with those who lived on the other side of the hill. It was a long and hard struggle, but that's just about what happened. In the end, Garrison was not the only one who had gone "over the top."

The black community on the north slope began to organize. In 1806, the blacks formed their own church, the African Meeting House, the first

The African Meeting House.

in the nation. It stood at Smith Court and Joy Street and is still in place. Its basement served as the school for black children until 1830, when a white merchant, Abiel Smith, founded a school next door to it. The meetinghouse also served as a meeting place during the hectic times prior to the Civil War.

The organization of Beacon Hill's black community grew ever more organized in the decades before the Civil War, and its people learned to work with their white neighbors, the abolitionists from the south slope, for a common cause. While individual blacks showed immense courage, as did groups of blacks, the outcome would not have gained traction without the white abolitionists like William Lloyd Garrison, William Ellery Channing, Wendell Phillips and Charles Sumner, all part of the Brahmin caste.

Sumner criticized his own neighbors who, like many in Boston, turned their heads away from the evils of slavery since they relied upon slave-grown cotton to run their mills. He spoke harshly of an "unhallowed union between the lords of the lash and the lords of the loom." That was indeed the conflict. It was the reason why some Bostonians were slow to abandon their support for the southern planters. It may be hard to imagine now, but abolitionists could not count themselves safe on the streets of Boston in the early 1830s. Their neighbors had too much at stake in slavery's survival. Sumner was calling them out. He was also following a technique that Garrison preferred and espoused.

Garrison was easily the most active of the group. He founded the New England Anti-Slavery Society at a meeting at the African Meeting House in 1832 after having been denied the use of Faneuil Hall.

William Ellery Channing was more moderate. He was a minister who was seen as a moderate—at least at first. But in 1837, he called for a rally to protest the murder of Reverend Elijah Lovejoy by a proslavery mob in

Alton, Illinois. Channing, too, had asked for the use of Faneuil Hall, but the mayor foolishly refused. A public outcry forced the mayor to reverse himself, and the hall was packed as people of all stripes made common cause.

Channing wrote a pamphlet that showed the bad effects of slavery on both slave and master. His pamphlet served as a kind of "trigger" that set off widespread support for abolition. This was the kind of "permission" needed by moderates. His writing made it all right for middle- and upper-class people to openly oppose slavery. Abolitionists also gave poets and writers a noble cause to fight and write for, while orators like Wendell Phillips and Charles Sumner won people over with their silver-tongued but emotional speeches.

William Ellery Channing.

Neighboring slopers like Harrison Gray Otis and Nathaniel Appleton had no use for abolitionists like Garrison. When Garrison published *The Liberator*, Otis predicted that its ideas wouldn't be accepted by the respectable class. Appleton believed that slavery was a problem for southern states to solve.

But others supported Garrison while favoring more moderate positions, such as gradual emancipation. Wendell Phillips, son of Boston's first mayor, modeled his support rather on the work of John Hancock. He said, "Old families run to respectable dullness. Snobbish sons of fathers lately rich, anxious to show themselves rotten before they are ripe."

Old Boston families like the Quincys, Adamses, Westons, Sewalls, Phillips and Lorings, especially the younger members of these families, were often affected by an in-house polarization. Like their forebears in the Revolution, and like young Americans of the 1960s, the young wanted a cause to fight for, and Garrison was providing it. Many of the young women identified with the movement and also saw it as a chance for them to use their education

and wealth for a real cause, as Abigail Adams had done before them. From this would stem a fight for women's rights.

Frederick Douglass said of Garrison that he was a man who "moved not with the tide, but against it. His zeal was like fire, and his courage like steel."

Born and raised in Newburyport, Garrison got into newspaper writing and publication both there and in Boston and in Vermont. His themes always ran to morality, first favoring temperance and later opposing slavery. With Quaker Benjamin Luddy of Baltimore, he co-edited *Genius of Universal Emancipation*, a newspaper espousing immediate freeing of the slaves. It was a stance at which he would become stalwart and stubborn.

However, it was not until he came back to Boston and began to publish *The Liberator*, starting on the first day of the year 1831—the first of 1,819 weekly issues—that he drew great attention to himself and his views. That first issue thrust forth these bold and memorable words: "Within sight of Bunker Hill and in the birth place of liberty, I will be as harsh as truth, and as uncompromising as justice. On this subject, I do not wish to think, or speak, or write, with moderation...I am in earnest—I will not equivocate—I will not excuse—I will not retreat a single inch—AND I WILL BE HEARD."

He was right. He was heard. And immoderate as he might be, he could not be overlooked.

Although he did not believe in the Constitution or in voting, he listed voting places in his paper and said which candidates would be better for blacks. He opposed violence but defended blacks who used it. He admired Illinois editor Elijah Lovejoy, who armed himself against angry mobs and was killed by a mob in 1837. Many blacks disagreed with him about the rightful use of violence and on the Constitution. It was that document and the Declaration of Independence that offered the rights to which they aspired. Most blacks wanted to work within the system.

He thought it was possible to convince slaveholders to free their slaves by persuading them that what they were doing was wrong. He had a retort for the "gradualist" too—the person who thought slavery could and would be abolished by having it become an economic burden or a political one, and those who believed that public opinion would at last take hold and bring about abolition. He said to them: "I know not by what rule of the gospel men are authorized to leave off their sins by a slow process."

Here it was again—the religious underpinning. Slavery was evil, thus a sin, therefore must be expurgated, not allowed to shrivel on the vine. A modern equivalent might be pro-lifers who consider abortion to be killing, which is evil and can't be moderated.

The North Slope

It probably is not surprising to learn that 75 percent of the subscribers to Garrison's *The Liberator* were black. It had, for them, the additional benefit of providing news of the local black community and editorial material supportive of causes that they also backed, rather monolithically.

However, the black community wasn't his only *intended* target. His magazine was mailed all over the country. But it was viewed as dangerous for stirring up issues that ought to lie dormant, according to many whites, and in the South it brought about violence when mobs broke into post offices and burned copies of his publication. The State of Georgia even placed a bounty on Garrison's capture, and it was not alone.

That didn't mean that northern whites were indifferent. Many in the business community considered abolition bad for business and meant to stop it—by violence, if necessary. Even in liberal Massachusetts, supporters of abolition lost their jobs and positions, were kicked out of colleges and socially isolated. Free speech, which got its greatest boost in Boston, was not so free when it was costly to business.

Garrison, himself, was attacked by a mob in October 1835 on the streets of Boston. Among them he claimed there were men of property and position. He inadvertently showed the naiveté that perhaps lay behind his belief in moral suasion. He was heard to exclaim as the mob tried to tear him apart: "Oh, if they would only hear me five minutes, I am sure I could bring them to reason."

That was not likely, and fortunately for him he got no chance to try because the mayor was able to spirit him away and clamp him safely in jail for the night where the mob could not get at him.

Many of the abolitionists, like the civil rights activists of later times, showed great physical courage, even seeking opportunities to stand up for their beliefs. David Walker, noted black abolitionist, wrote a pamphlet, *David Walker's Appeal to the Coloured Citizens of the World*, denouncing slavery, calling it the worst in world history and calling on blacks to resist by every means. A price was placed on his head in southern states.

Walker handed out his pamphlet through black civic associations in northern cities and tried many different schemes to get the pamphlet into the hands of slaves and free blacks in the South. Most newsworthy, however, were the actions taken by white authorities in Savannah, Georgia, who seized dozens of copies of the pamphlet that had been smuggled in by black sailors (who had bought jackets from Walker in Boston with copies stitched into the lining). Then they banned black seamen from coming ashore at the city's port at all. The mayor of Savannah, where it was illegal to teach a slave

to read, demanded that the mayor of Boston arrest Walker and outlaw the pamphlet. (Boston's mayor refused the order.)

In the *Appeal*, Walker argued that African Americans suffered more than any other people in the history of the world. He said that was partly the fault of blacks, who were too submissive to whites, but also blamed Christian ministers for a lack of help and groups like the American Colonization Society (ACS), which would have taken blacks to West Africa and freed them there. The ACS plan was to send blacks to Liberia and Haiti, but in Liberia they were still controlled by whites, and living conditions were harsh in Haiti, then as now. Whites who supported ACS often wanted blacks out of the country and under the economic control of whites. Most blacks distrusted the whites who supported it and were concerned that sending free blacks out of the country would have a negative impact on emancipation hopes. Many south slopers supported the ACS and had formed a Massachusetts branch of it. Walker condemned this, calling instead for total and immediate emancipation of slaves, and even suggesting that slaves take their freedom by killing their masters.

FUGITIVE SLAVES AND THE UNDERGROUND RAILROAD

O ther blacks came to the fore in the effort to help runaway slaves. Such a fugitive slave was George Latimer, who had escaped from bondage in Virginia but was pursued by his owner, John Gray, who applied to the Massachusetts Supreme Court to have him returned to slavery. Latimer was defended by Frederick Douglass, Elias Gray Loring, Charles Lenix Remond and Wendell Phillips. But meanwhile, he remained in jail.

His lawyers argued that he hadn't been charged with a crime and shouldn't be held by Massachusetts authorities in a state jail. Ellis Gray Loring met with Latimer and tried to get him freed but failed. Meetings were held every night in the Afrifcan Meeting House to raise money to free him. The slaveholder John Gray then changed his mind and said he'd take $400 for his slave's freedom.

Though Latimer was freed, it hadn't been through the legal process, so it hadn't settled anything. The reality was that even though Massachusetts had outlawed slavery, escaped slaves were not free there, and southerners who visited the Bay State could actually *bring* their slaves with them. Black Bostonians and abolitionists addressed this by gathering sixty-five thousand signatures on a petition and persuaded the state legislature to pass the 1843 Personal Liberty Law, which said that state facilities and officials could not be used to capture fugitive slaves.

These moves rather vindicated Garrison's view that moral suasion and the legal system could accomplish more than violence could. Bostonians were beginning to be convinced. Those called "Conscience Whigs" also came to understand that slavery was immoral, that it was not only harmful to slaves

but also to slaveholders (the sin corrupting the soul) and to the political and economic interests of the nation.

Along with civil rights for blacks, many of the same people began to argue for rights for women. Lucretia Mott and Maria Weston Chapman founded the Boston Female Anti-Slavery Society, and Garrison agreed with them that women should have equal prominence in the antislavery movement. Other men, however, disagreed.

And even though abolitionists disagreed on some issues, they continued to work in unison. They worried that slavery was really ruling the country. Even in the North, raw materials like cotton, produced by slave labor, were needed to keep the economy growing.

A Beacon Hill resident who did as much as any white person for the cause was Charles Sumner of Beacon Street. He had been born on the north slope of the hill, where his father, a sheriff, had treated his black neighbors with a civility that was uncommon in that day. Charles adopted that attitude and appreciated the role of the underdog since he had been discriminated against and ostracized by his richer schoolmates because of his humble background. He had gone on to Harvard, passed the bar and become a successful lawyer.

But he was dissatisfied, and when he read *The Liberator*, he found that he agreed with Garrison, except for his views on the Constitution, and he wanted to use the law to bring equality to all citizens. In 1848, he joined the Free Soil Party, which wanted to prevent the spread of slavery to western territories.

Another who joined them was Wendell Phillips, attorney and son of Boston's first mayor—another south sloper. Though a wealthy aristocrat, he had become radicalized by the mob treatment of Garrison and the murder of Elijah Lovejoy in 1837. He was also one of the best public speakers in the country.

Success came a step at a time. There were numerous points of contention: the African School, established by the black community, had been paid for by the families and by contributions. Finally, one of the teachers convinced a wealthy white merchant, Abiel Smith, to give $5,000 a year in perpetuity to the school. After that, the Boston school system agreed to run it—one of the first cities in the country to run a school for black children.

But the curriculum was poor, offering only the basic subjects; the funding was quite unequal; and the rooms were crowded and noisy. David Child (husband of activist Lydia Maria Child) issued a report that showed all of the problems mentioned above, plus the unsanitary conditions at the Smith School, and asked the city to give equal funding to it. The city built a new Smith School, but it was inadequate and it had to house black children from

Fugitive Slaves and the Underground Railroad

all over the city at the corner of Belknap Street and Smith Court on Beacon Hill. Most of the problems remained.

Robert Morris and Charles Sumner, meanwhile, sued the school committee on behalf of a black child who was not allowed to attend schools near her home and had to go to Beacon Hill to attend the Smith. Sumner argued that Massachusetts had no precedent for segregated schools, and the state constitution gave equality to all regardless of race. The judge, however, laid out the "separate but equal" argument that would be used for another hundred years and more.

The abolitionists tried other ways. In 1843, they got the legislature to forbid racial discrimination on railroads and other vehicles and to allow interracial marriages.

At last, in 1855, Boston desegregated its public schools, but by that time the focus of the black and abolitionist community was on fugitive slaves, a long-standing irritation between North and South. The Constitution, in Article 4, had a clause stating: "No person held to service or labor in one State, under the laws thereof, escaping into another, shall, in consequence of any law or regulation therein, be discharged from such service or labor; but shall be delivered up on claim of the party, to whom such service or labor may be due."

Abolitionists in Boston and elsewhere had, nonetheless, evaded the law and managed to help slaves escape to Canada and elsewhere. Enforcement was difficult. But the Compromise of 1850, cobbled together by Kentucky senator Henry Clay, Illinois senator Stephen Douglas and Massachusetts senator Daniel Webster, allowed two new free states to enter the Union in exchange for a new, stricter Fugitive Slave Law. (Webster was now considered a traitor in Massachusetts.)

At that point, North and South were arguing over the possible expansion of slavery to new territories and states. As a sop to the South, this provision was thrown in. It stated that all prosecution of escaped slaves would take place in federal, not local, courts, and personal liberty laws like the one Massachusetts had passed in 1843 after the Latimer case were laid aside. Since proof of freedom became the burden of the accused rather than the slave master, thousands of Boston blacks who may not have had convincing papers feared for their safety even though many had jobs and were established in the community.

Many of them decided to flee to Canada. Some were able to do that at once, but others needed help—places to stay, food and transportation. A group called the League of Freedom was formed under Lewis Hayden.

When white abolitionists met at the African Meeting House to form the Boston Vigilance Committee, Hayden persuaded the League of Freedom to form an alliance with them. He was a valuable go-between who helped cement relations between the black community and the white abolitionists. Together, they planned to raise money to mount legal challenges to the Fugitive Slave Law. Men such as Charles Sumner, Elias Loring and Robert Morris enlisted to defend runaways.

Lewis Hayden was born a slave. He and his wife successfully escaped slavery in 1844. They settled in Boston, where they became active participants in abolitionist activities. In 1850, the Haydens assisted a fugitive slave couple, William and Ellen Craft, who had escaped from Georgia. This was a celebrated case, for the escape was creative in design. The light-skinned Ellen Craft disguised herself as a white male slaveholder, and her husband pretended to be her servant. After a long journey, they made it to Boston in 1849, where he opened a shop as a cabinetmaker on Cambridge Street while Ellen, a skilled seamstress, learned upholstery from a white abolitionist, Susan Hillard. The couple stayed with the Haydens on Southock (now Phillips) Street.

Within less than two weeks, a slave catcher from Georgia secured a warrant for their arrest. This news spread quickly. The Vigilance Committee began plans to get the Crafts out of Massachusetts. They also harassed the slave catchers, passing out handbills that acted almost like wanted posters to show what they looked like. Within a month, the slave catchers had left Boston, and the Crafts escaped to England, thus proving the effectiveness of the resistance.

Lewis also led in the well-publicized rescues of Fredric Wilkins, alias Shadrach Minkins, from a courtroom at the head of fifty blacks and spirited him to a safe house in Concord, prompting abolitionist minister Theodore Parker to call it "the noblest deed done in Boston since the destruction of the tea."

The case of Anthony Burns was a decisive one in converting fence sitters to the abolitionist cause. Burns was a nineteen-year-old runaway slave from Virginia who had reached Boston and was working at a clothing shop on Brattle Street. He was also a member of the nearby Twelfth Baptist Church, whose minister was the abolitionist Leonard Grimes, also a Virginian by birth.

"I got employment, and I worked hard; but I kept my own counsel, and didn't tell anybody that I was a slave," he said. But he made a serious mistake. He wrote to his brother back in Virginia, and the letter was intercepted by his

master, Charles Suttle, who came to Boston to reclaim him. Burns was arrested and placed in a jail on the third floor of the federal courthouse.

Burns's arrest became big news in Boston, for it coincided with a lot of other news, both local and national. The city was hosting conventions of both abolitionists and prominent women's rights groups. Hundreds of people were in town for that, one of whom was especially noteworthy: Harriet Beecher Stowe was in town, author in 1852 of *Uncle Tom's Cabin*, a fictional work that would sweep like wildfire through the northern states. Stowe's portrayal of the effect of slavery on black families galvanized antislavery opinion, especially among the middle and upper classes.

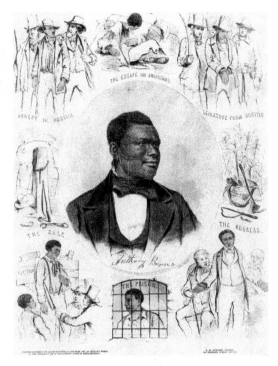

Anthony Burns.

Abraham Lincoln called her book the cause of the Civil War. It certainly affected the operation of the Fugitive Slave Act, which was actively opposed in Boston. The book was reviewed internationally and today has more versions than any book but the Bible. Harriet's father, Lyman Beecher, was minister of the Park Street Church, so Harriet often visited Boston. She had visited the Lewis Hayden house at 66 Phillips Street, where he harbored fifteen runaway slaves and had mined the foundation with gunpowder, which he said he would ignite rather than surrender.

The national news was the passing of the Kansas-Nebraska Act by Congress, nullifying the Missouri Compromise and leaving the question of slavery in the territories and new states to "popular sovereignty," a concept espoused by Stephen Douglas, who would soon debate with Abraham Lincoln about whether states should decide for themselves if they were to have slavery. Lincoln argued against it.

Stowe's *Uncle Tom's Cabin.*

Beacon Hill's abolitionist Senator Charles Sumner thought the act was an outrage: "It annuls all past compromises with Slavery, and makes all future compromises impossible. Thus it puts Freedom and Slavery face to face, and bids them grapple." Tensions were exceptionally high that May 1854 in Boston, and the Burns battle was right in the midst of it.

The Boston Vigilance Committee (BVC) decided to hold a meeting of its own. It had decided to use legal tactics to delay the case but agreed that it might take more than that. An emotional crowd of five thousand gathered at Faneuil Hall on the evening of Friday, May 26, 1854. Wealthy merchant George Russell, a founding member of the BVC, opened the meeting and immediately set the tone: "The time will come when Slavery will pass away...I hope to live in a land of liberty—in a land where no slave hunter shall dare pollute with his presence."

The large crowd undoubtedly agreed with Russell, as it must have with Wendell Phillips, who cried out: "If Boston streets are to be so often desecrated by the sight of returning fugitives, let us be there, that we may tell our children we saw it done. There is now no use for Faneuil Hall. Faneuil Hall is the purlieus of the Court House to-morrow morning, where the children of Adams and Hancock may prove that they are not bastards. Let us prove that we are worthy of liberty."

Phillips used the forum for a twin attack. He called the Kansas-Nebraska Act "knocking a man down and this [the arrest of Burns] is spitting in his face after he is down." He asked the crowd to storm the courthouse on the morrow and rescue Burns: "See to it that tomorrow, in the streets of Boston, you ratify the verdict of Faneuil Hall, that Anthony Burns has no master but God."

After Phillips's astounding words, Reverend Theodore Parker, whose grandfather had stood up to the British at Lexington, had his say: "I love peace," said Parker, "but there is a means and there is an end; liberty is the end, and sometimes peace is not the means towards it." Parker advocated violent action: "I have heard hurrahs and cheers for liberty many times; I have not seen a great many deeds done for liberty. I ask you, are we to have deeds as well as words?" The crowd screamed, "Yes!"

But the Faneuil Hall group would not meet in the morning. A mob of blacks gathered outside the courthouse and broke down the door. The Vigilance Committee ran out of Faneuil Hall to join them, but military were called in and quelled the riot.

President Pierce sent U.S. Marines to defend the courthouse, saying, "The law must be executed." When the trial began the following Monday, the federal courthouse looked like a fortress. Security must have been tighter than at a twenty-first-century airport.

It would be no ordinary court hearing or trial. The sole judge was the commissioner, Judge Loring. Richard Henry Dana, defending Burns, appealed to Loring's humanity, saying that he should listen to a higher law and release Burns from slavery because it was the right thing to do. "Ask not, Is it constitutional. Ask, Is it right?"—a phrasing that would be echoed one hundred years later by John F. Kennedy. "If [you decide] against him, a free man is made a slave forever...The eyes of many millions are upon you, Sir. You are to do an act which will hold its place in the history of America... May your judgment be for liberty and not slavery."

Loring handed down his verdict on June 2, 1854, under further tight security. Loring went with the written law rather than the natural one and ordered Burns returned. A crowd of fifty thousand filled the streets at 2:00 p.m. as Burns was escorted out of the courthouse.

In a dramatic scene, the shackled Burns, flanked by one thousand military, was led the short distance down State Street to the dock where a ship was waiting. The citizenry was stunned by the reality of seeing a chained slave on the streets of Boston. Many in the huge crowd jeered and yelled. Buildings were draped in crepe, and American flags were hung upside down from nearby buildings. A Boston attorney watched the procession from his office window, admitting, "When it was all over, and I was left alone in my office, I put my face in my hands and wept."

Amy Lawrence said this about the effect of the trial on Boston: "We went to bed one night old-fashioned, conservative, Compromise Union Whigs and woke up stark mad Abolitionists." At a huge July 4 outdoor meeting held

in nearby Framingham a month after the Burns decision, William Lloyd Garrison burned a copy of the 1850 Fugitive Slave Law and then a copy of Judge Loring's written decision in the Burns case. Finally, Garrison held up a copy of the U.S. Constitution and set it ablaze, condemning it as "a covenant with death and an agreement with hell." In the end, Burns's freedom would be purchased by his supporters; he would return to Boston, attend Oberlin College and become a Baptist minister of a church for fugitives in Ontario.

Events continued up to and into the Civil War, which began in April 1861. Abolitionist Charles Sumner, having made a speech criticizing South Carolina as part of his many attempts to destroy what he called the "slave power" of the South, was attacked violently in the Senate by a cane-thrashing congressman, Preston Brooks, from that state and left bleeding on the floor. Following this 1856 attack, Sumner became a hero in the North, while Brooks received many gifts of canes from his southern supporters, in an event that only strained already tense relations. It took years for Sumner to recover, but he went right back to the Senate during the Civil War, where he became a radical leader.

The fiery John Brown, who aided Free Soilers in Kansas, was supported by the abolitionists, including Garrison, who contributed $100,000. Brown was killed during his attack on a U.S. arsenal in Virginia. Part of his support came

SOUTHERN CHIVALRY — ARGUMENT versus CLUB'S.

The caning of Charles Sumner.

from the "Secret Six," a group that included three Bostonians: Theodore Parker, Thomas Wentworth Higginson and Samuel Gridley Howe. After the failed attack, they and Frederick Douglass fled for a time to Europe.

Governor John Andrew, an abolitionist and Lincoln supporter, took office just before the start of the Civil War and quickly put the state on a military footing. He also recruited volunteers from other states to serve in Massachusetts regiments. When President Lincoln asked for troops to protect the nation's capital, Andrew sent four regiments who went through a scuffle in proslavery Baltimore en route to Washington.

At his home on Southac Street, Lewis Hayden entertained the governor on Thanksgiving and asked him to create an all-black regiment. Frederick

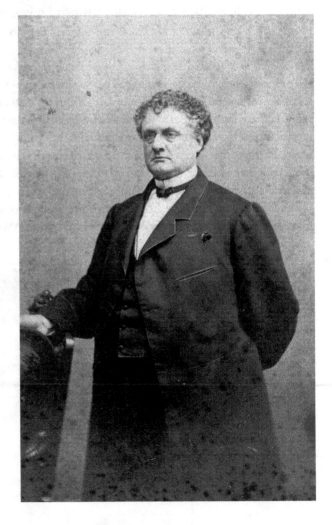

Governor John Andrew.

Douglass helped to recruit the men. The first all-black regiment would be the Fifty-fourth Massachusetts, followed by the Fifty-fifth, and Andrew wanted an abolitionist to lead it. He picked Beacon Hill's Robert Gould Shaw.

The Fifty-fourth saw action at Fort Wagner off the coast of Charleston, South Carolina, suffering the loss of about a third of its men, including Shaw. The Confederate general returned the bodies of the other Union officers who had been killed. He said he would have done the same for Shaw if he had been commanding white troops, but instead he left Shaw's body buried in a mass grave with his soldiers. Shaw's father said that he was proud to know that his son was buried with his troops, since he was a soldier and a crusader for social justice. He said, "We would not have his body removed from where it lies surrounded by his brave and devoted soldiers...We can imagine no holier place than that in which he lies, among his brave and devoted followers, nor wish for him better company—what a body-guard he has!"

Another group that made an impact during the Civil War, the Irish had not been viewed as eager to integrate into the population of Boston, but they saw the war as one for all Americans, and they volunteered in large numbers, making excellent soldiers. In fact, the Ninth Massachusetts Volunteers, commanded by Thomas Cass, was all Irish.

While the Irish viewed the war as a patriotic cause, Governor Andrew agreed with Frederick Douglass, who helped recruit the black troops, that it was a war about slavery, not just about the Union, as Lincoln had been saying. This idea had yet another Boston link: troops on George's Island in Boston Harbor, under the command of Daniel Webster's son, Fletcher,

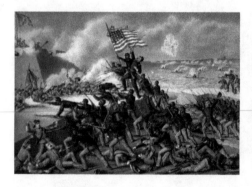

Above left: The attack on Fort Wagner.

Above right: Saint Gaudens sculpture on Boston Common memorializes Robert Gould Shaw and the Fifty-fourth Massachusetts volunteer infantry (all African American).

had a man in their regiment called John Brown—not the radical of Kansas. They made up a song about him that became popular until the U.S. Army commanded that they stop singing it because the war was not about slavery, it was to save the Union. But that didn't stop the singing.

On an inspection tour of the troops in the fall of 1861, Samuel Gridley Howe and his wife, Julia Ward Howe, heard men singing the song. Julia couldn't get the tune out of her mind. She woke up in the middle of the night hearing the sound in her mind and remembering the marching men. She sat down and wrote new lyrics for the song. When she got back to Boston, she sent a copy to J.T. Fields, her friend and publisher of the *Atlamic Monthly*. He paid her five dollars and printed the song on the first page of the Feburary 1862 issue of the magazine. Its words and the song "The Battle Hymn of the Republic" would be sung wherever Union troops went. The first stanza goes like this:

Mine eyes have seen the glory of the coming of the Lord,
He is trampling out the vintage where the grapes of wrath are stored.
He has loosed the fateful lightning of his terrible swift sword.
His truth is marching on!
Glory, Glory! Hallelujah! Glory! Glory! Hallelujah!
Glory! Glory! Hallelujah!
His truth is marching on!

MILLING AND FILLING

The Back Bay

The origin of the name "Back Bay" may seem lost in the mists of history, but it was a perfectly logical name for what is now dry land. It was a bay before a lot of infilling took place in the second half of the nineteenth century. The present toney neighborhood with its few tall buildings and many cultural, medical and educational institutions was once a wide expanse of water that lay to the west of the Shawmut Peninsula, the main part of Boston. That means it was in *back* of the main part of Boston if we consider Boston Harbor to be in *front* of it. That's how the Bostonians of the day saw it, so they called the inlet "Back Bay."

This bay spread out between Boston and Cambridge, with the Charles River on the northwest side of it. The bay was brackish and tidal. When the ocean tide rose twice a day, the water in the Back Bay rose several feet, and at the low tide some of the bottom of the bay lay bare.

In fact, well before the time of the Puritans, Native Americans, recognizing the rise and fall of tides, built fish weirs across the tidal flats as a simple and sure way of catching fish each spring, or at least letting the tides do it for them. Archaeologists verified the authenticity of these weirs when they were first uncovered. The tides brought the fish into the basin, the nets caught them and held them and the Indians hauled in their catch when the tides went out again. The discovery of those weirs happened at the time the subway was being dug through the area along Boylston Street in the early twentieth century.

But all that is merely a sidebar to the story of the digging for a subway. For nearly one hundred years before that, Back Bay, like other parts of Boston,

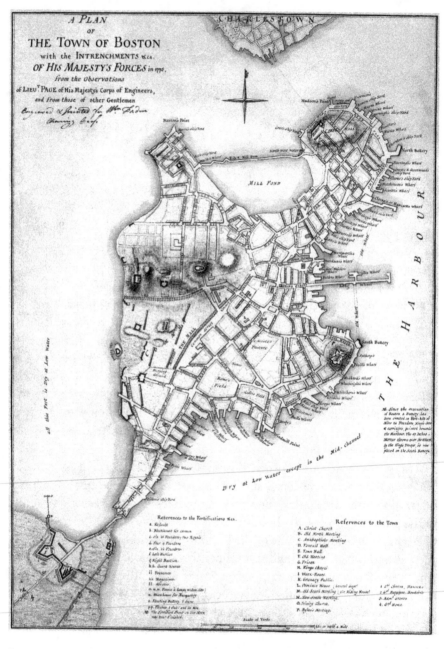

Boston, 1775.

was in the process of being filled in. People could have given you three reasons for filling in the bay: first, it stank at low tide; second, the tidal movements could be used to generate power for industry; and third, traveling west across the bay would make a shorter trip to towns in that direction.

All the work began in 1814, when a charter was given to the Boston & Roxbury Mill Dam Company to build a milldam across the expanse of the bay and to build a road atop it. The dam ran approximately along the line of today's Beacon Street as an extension of the road that ran down Beacon Hill to Charles Street. It was built from there to Kenmore Square, and the road on top allowed travelers to reach Watertown without going through Boston Neck. In fact, some Sunday afternoons Bostonians, especially young, courting couples, went for drives out along the new road.

To the planners, the road was a secondary consideration. The main purpose was to provide power for industrial use. The milldam project was the baby of Uriah Cotting, a shareholder in the Boston Manufacturing Company, real estate promoter and amateur engineer. Cotting's previous work had included the modernization of the waterfront, where he supported Charles Bulfinch's building of India Wharf and the storehouses on top of it—one of many Bulfinch designs—a body of work that included most of the other major development projects in Boston from 1800 to 1820.

Cotting wanted to harness the tidal flow of the Charles River by building two dams, the one along the line of Beacon Street and the other from Boston to South Boston. His idea for a dam in South Boston was quickly put aside, but a second dam *would* be built in another place. Cotting's brainstorm came during the War of 1812, when manufactured goods were still hard to come by due to hostilities and embargoes, and at a time when industrial production was practically nil. Cotting saw the need for power, especially water power to drive industry, but his timing was a tad too late. (Think "Waltham.")

The major dam that would actually be built was the one that extended the line of Beacon Street from its terminus at the foot of Beacon Hill at Charles Street to Sewell's Point, Brookline, which is now Kenmore Square. A second dam would be built roughly perpendicular to the first, from Gravelly Point, Roxbury (today's Hemenway Street), dividing the basin in two. This had the effect of dividing Back Bay into two basins on either side of the dam. The developers expected that new factories would be built near the Roxbury end of the second dam.

The major dam had five sets of doors that closed against incoming tides, keeping water out of the upper or westernmost basin. To augment the amount of water in the full basin, they set things so that the high-tide water

Map of the
milldam.

was let in twice a day from the Charles. The water from the full basin ran through millraces continually to power the mills on Gravelly Point.

The water in the receiving basin was kept as empty as possible by drawing its water through the dam and back into the river at each low tide. That meant that the water through the millraces would fall a maximum amount, but it also meant that this basin was highly polluted.

This flowing of water through the dam and its sluices would produce power, which Cotting believed would accommodate eighty-one factories or other industries along the basin—if he was right.

Most thought he was. Most people scrambled aboard the express that was Cotting's Back Bay power plan. But not everyone. A letter to the *Daily Advertiser* early in 1814 expressed reservations:

> *Citizens of Boston! Have you ever visited the Mall?* [on Boston Common near the edge of the basin] *Have you ever inhaled the western breeze, fragrant with perfume, refreshing every sense and invigorating every nerve? What think you of converting the beautiful sheet of water which skirts the Common into an empty mud-basin, reeking with filth, abhorrent to the smell, and disgusting to the eye? By every god of sea, lake, or fountain, it is incredible.*

Milling and Filling

That, however, was a lonely opinion. People were in a mood for industrial development in the same way that young people at the turn of the twenty-first century were ready for new technology. It was easy to convince the Commonwealth of Massachusetts that the milldam plan was a good one. On June 14, 1814, the incorporation of the Boston & Roxbury Mill Dam Corporation of Cotting, Isaac Davis, William Brown and associates was approved. The legislature also authorized the sale of 3,500 shares of stock to get it going, although economic conditions, and the difficulty of attracting private investors, would delay sales of this stock until 1818.

Cotting, who wrote the prospectus, estimated a cost of a quarter of a million dollars but an income of half a million per year. That sounded like a deal too good to miss. One investor even crawled through the window of Cotting's office in order to get in (symbolically) on the ground floor.

But perhaps that four-year delay in selling stock caused Cotting to miss the economic high tide, and the pent-up demand for power had already slipped away on the low tide of economic demand. The harnessing of the Charles River at Waltham had begun, and the need for hydropower near the heart of the city was slim. The project failed miserably.

The costs were nearly three times what had been expected, and the returns were closer to $6,000 a year than the gaudy half million predicted. Only three, rather than the predicted eighty-one, manufacturing companies used the power that was offered. Cotting had died two years before the project was finished, his reputation sadly besmirched. Still, if he had lived long enough, it may have been restored, for the city would recover from this false start and turn the area into a pricey residential area rather than a downtown industrial zone. The Victorian Back Bay that was to come would be an architectural jewel and the most desired section of Boston.

Before that came about, the road atop the dam did give Bostonians quick access to towns on its western side like Brookline, Brighton, Cambridge and Watertown that formerly had to be reached via the long route through Boston Neck or across the wooden West Boston toll bridge to East Cambridge. (This is the location of today's Longfellow Bridge.) Riding across the milldam was quicker by six miles, but it also provided riders those foul odors mentioned in the letter above, and it, too, required paying a toll halfway across.

Still, farmers from Brookline and Newton brought their corn to the mill and then to Boston. On the western end near Sewell's Point, the road forked. The branch to the right (now Commonwealth Avenue) ran to Brighton, while the "Punch Bowl Road" to the left—named for a tavern by the same name at the railroad tracks near the present Fenway Park—became Brookline

Avenue. Above the road at that point was a large sign: "Railroad Crossing: Look out for the Engine while the bell rings." (This may be viewed as an early example of grade crossing safety.)

The dam was later buried under present-day Beacon Street and is still there, but in due time it was decided to fill in the tidewater area called the Back Bay and create residential lots.

Three years after the opening of the dam, the first lands within the Back Bay were filled in. In February 1824, the city purchased, for $55,000, a series of ropewalks located at the base of the Common on the opposite side of Charles Street. This land had been given to the proprietors of the ropewalks years before, and now the city had to buy it back. It was a spot where Ben Franklin had gone fishing as a boy.

Now it belonged to the new City of Boston, which had gained its charter in 1822. Right away, there was a conflict. Developers were anxious to acquire the land in order to build, but Mayor Josiah Quincy, reacting to a public outcry, submitted a proposal the following July to annex the land to the Common, making it a public garden. This initial filling demonstrated the market value of the new land and was just a hint of the changes that were to come to the Back Bay.

This land was called the Public Garden and would eventually become part of the seven-mile park system known as the "Emerald Necklace." The Garden was designed by George Meacham of Watertown, and the flowerbeds

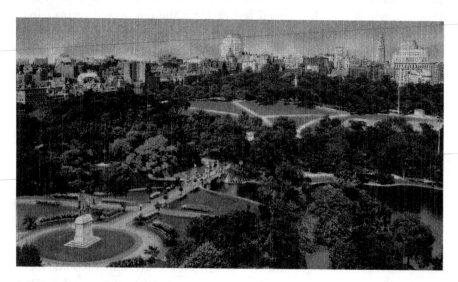

Boston Public Garden.

66

were primarily set up by an Irish American horticulturalist named William Doogue. He worked with great vigor and became famous for bright floral displays and tropical plants, though some called them inappropriate.

The Public Garden is also known for its swan boats. These came to be in 1870, when Robert Paget, a shipbuilder, started the concession on the lagoon. He had planned to use rowboats, but when he saw the opera *Lohengrin*, in which a knight crosses a river in a boat drawn by swans, he decided upon that motif, and so it remains.

Despite the four-year waiting period while financial backing was raised, the plan wasn't very good. In fact, there wasn't much of a plan. A project of that magnitude, we now know, demands a point by point timeline, clear titles to property, studies of outcomes (particularly environmental ones) and the needed authority for each step.

Another force that had to be factored into this development was the coming of rail transportation. Two railroads were built through the Back Bay starting in 1831 and completed by 1835. The first line was the Boston & Worcester (later extended to Albany). It followed a line that parallels today's rail line to Allston, a line that now runs alongside the Mass Turnpike Extension. It ran east from Sewell's Point over a trestle bridge across the first basin, then across Gravelly Point to the receiving basin, reaching land near the present intersection of Arlington and Tremont Streets. From that point, it went by land to the area of today's Lincoln and Beach Streets.

During the building of the line, part of the South Cove was filled in to make a terminal and yards for this line. That terminal was in today's leather district, not far from the present South Station. Land was also filled where Chinatown is now.

That wasn't the end of the railroad building, however. The Boston & Providence line also crossed Back Bay. The tracks for this railroad, which ran on a Dedham line and a Stoughton line, came into Boston mainly along the route of today's Orange Line of the MBTA out of Roxbury. They ran across the receiving basin, crossing the Boston & Worcester tracks at a large cross near the location of today's Back Bay Station on Dartmouth Street. This railroad's terminal was not far from where Park Square is today.

When Cotting's project began, you'll recall, they hadn't developed an overall plan. Industries didn't get on board as expected, the railroads built the causeways without coordinating with the developers and each additional thing that was built had changed the water level. Now the river could no longer flow easily in and out. People who lived nearby had gotten used to dumping their trash in the bay, and there was also the sewage from the ever

more populous area. The stench that had always been noticeable at low tide was worse.

When the damming up of the basin curtailed the flushing of sewage and other impurities, the Board of Health worried about diseases such as cholera and dyptheria. By the 1840s, the stench had become really bad, and in 1849 the health department declared the area a "nuisance, offensive and injurious to the large and increasing population residing upon it." They believed the solution was to fill in the bay and create new land.

That was one of three reasons for the filling in of the Back Bay. A second was the need for more residential land. The third reason was more political and social in nature. The wealthy people had become crowded into their Beacon Hill enclave, and some had moved to the suburbs. (By 1850, about twenty thousand people were commuting to Boston by train each day.) The population was becoming more and more made up of Irish and other immigrants. The Protestant leadership did not like these social developments and wanted to keep the merchant class in the city. They would need another "enclave" in a pricey neighborhood close to downtown. Back Bay would fill that need if they filled in the bay, and the sale of lots at good prices would benefit the commonweatlh financially as well.

The filling in began in 1857. First they would lay three and a half feet of gravel, then soil would be spread on top of that. The gravel would allow the land to drain and would provide structural stability for the new surface. Most of the fill was gravel brought from the nearest location, which was East Needham, about nine miles by railroad over those causeways that had previously been built but traveling on a parallel track, and then by a spur line to the hills of East Needham, where gravel would be removed. This filling was a remarkable engineering feat.

The trains ran practically nonstop. They pulled thirty-five open cars that were filled by steamshovels that picked up the gravel in Needham. These trains made twenty-five trips in every twenty-four hours. The steamshovels, which had only been invented in 1839 by William Otis, could fill a swivel-style car in two scoops. The cars were brought right up to the excavation site, and the shovel operators would scoop their load and then elevate from the pit, turn toward the train car, open the bottom of its scoop and then go back for more. The train could be filled in ten minutes. It would have taken two hundred laborers to do the same work, leveling hills of fifty feet in height and making a flatland about twelve acres in size.

Once the trains reached Back Bay, the fill from the cars was placed in other cars to be towed by horses that ran over spurs on top of railroad

embankments to where the fill was to be laid. The embankments and the spurs were continually extended in several directions until the filling was complete.

These trainloads and fillings-in were able to cover two houselots per day. Eventually, filling materials were also taken from Hyde Park, Dedham and Canton. It took until 1882 to complete the filling in of Back Bay. The filling in had reached Kenmore Square by 1890 and was completed with some special work in the Back Bay Fens by 1900. It was one of several landfill projects that together doubled the acreage of Boston. The Commonwealth of Massachusetts filled in the land and then sold it to real estate developers. It was the largest landfill operation for residential and commercial uses ever undertaken in this country.

A great deal of preparation still had to be done once the filling was finished before streets and houses could be built. (Dioramas may be seen in the lobby of 501 Boylston Street in today's Back Bay that show how this was done.) Grading of streets and lots was particularly important, and later, as houses and buildings were placed on the lots, pilings had to be sunk to support the buildings. These were really just tree trunks and still have to be kept moist by the water level below ground to prevent their deteriorating. Trinity Church, which weighs almost ten thousand tons, has 4,500 piles. (The modern skyscrapers like the John Hancock Building and the Prudential Tower use steel sunk deeply into the bedrock.)

This filling still did not solve the sewage problem. It only became worse. By 1866, the city and commonwealth authorized the building of a sea wall and covering of more flats in hopes of abating the worsening nuisances of sewage (from Stony Brook and Muddy River) that sat on the flats and fermented in the sun. The problem was finally solved by transporting the outflow beyond the dam and eventually by sending it via pumping station to the ocean off South Boston.

Those who planned the filling in gave more thought to how the area should be used than the original developers had. Clearly, the space wouldn't do for industry, but the land was definitely needed and ideally located. The living space in Boston was limited by the cramped geography of the peninsula, and making Back Bay available offered a chance for a building bonanza with profits for the developers and for the state, which owned much of the land.

To make sure that this would become prime real estate, the developers took a page from the book of the Beacon Hill Associates by luring wealthy people to buy up the house lots. They made sure the land would be expensive so that lower-class people wouldn't try to get in on it. But upper-class people who

were interested in buying the lots might get a discount. They also enacted strict building codes so that the neighborhood would reach a high standard and have a uniform look to the buildings, which were mostly brownstones of three, four and five stories in height. These provisions led to the building of some of Boston's best architecture, much of which survives to this day.

This time, the planning was done before the building started—by several years—and they followed the street plan, which was an un-Bostonlike grid. The planners, Arthur Gilman and Gridley James Fox Bryant, were highly influenced by mid-nineteenth-century Paris, as designed by Baron Haussmann. Paris had recently been made a city of wide avenues, boulevards and monuments, and Back Bay would become somewhat like that. Gilman had recently visited London, too, where prominent English architects had taken him in hand. He was impressed by the grand boulevards in the West End, paricularly Kensington with its fine cultural and public buildings. The idea was to make Boston a cultural center, like these places, and to make the area attractive to potential wealthy buyers who would enjoy being near the Common and Public Gardens.

Commonwealth Avenue, which eventually ran from from the Public Garden west through Kenmore Square to Brighton and Newton, is based on Parisian boulevards. It's incredibly wide for a Boston street. In the Back Bay, it was made two hundred feet in width from the buildings on one side to those on the other, those buildings each being set back twenty feet from the

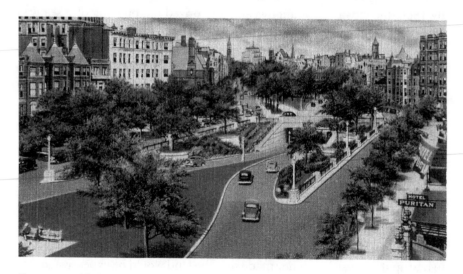

Commonwealth Avenue.

sidewalks. It also has a one-hundred-foot pedestrian mall down the middle, now planted with trees at planned intervals and studded with statuary.

Apart from this boulevard, the most important public area would be Art Square, a triangular area that would be renamed "Copley Square" after the artist. The square would be faced by the Museum of Fine Arts (for a period of time), by Trinity and New Old South Churches and later by the Boston Public Library. It remains a distinguished area in Boston.

Other wide streets are Beacon, Boylston, Massachusetts Avenue and Dartmouth Street, but Commonwealth (now called "Comm. Ave.") is the centerpiece. Besides Beacon, Boylston and Commonwealth, two other streets run east–west through Back Bay. They are Marlborough and Newbury. These one-way streets (except Commonweatlh) intersect at regular intervals with the north–south streets that are named alphabetically, starting at the Public

Art Square.

Garden: Arlington, Berkeley, Clarendon, Dartmouth, Exeter, Fairfield, Gloucester and Hereford, followed by Massachusetts Avenue (originally West Chester Park).

The filling of land began at the eastern end and worked gradually westward. Amazingly, as soon as land was made, plots were sold, and as plots were sold homes were built. That's why now, if you walk westward, you become aware of treading an architectural timeline where older buildings give way to newer ones the farther west you go. It's a veritable museum of housing of Victorian style. The buildings, thus, are different in architectural style but are similar in materials, whereas in the South End the brick and the style were similar.

The filling also caused a new problem. What had been a natural flood plain for the waters of the bay's tributaries—the Muddy River and Stony Brook—was no longer available. It had been made into dry land. Therefore, the Back Bay was in danger of flooding. By 1875, there was a proposal to make a park west of the alphabetical streets and Massachusetts Avenue for the purposes of alleviating actual or potential flooding problems. In other words, they wanted to create a storm water park, an idea that, at the time, was radical. The city also had the idea of creating a park system, but both these ideas would turn out differently than expected.

THE GREEN RIBBON

A n open competition was held to decide who would design the park at the Back Bay Fens, a marshy area, as the word "fens" suggests, that would need to be reconstructed. But the winning plan did not address the major problems, so Boston reached out to New York for the solution and invited the famed landscape architect Frederick Law Olmsted to come to Boston to work on it. Olmsted had just completed Central Park, and the City of Boston wanted his advice on developing a park system, especially in the Back Bay Fens. He began the Fens part of his project in 1878.

One of the world's most renowned landscape architects, Olmsted was not a Bostonian by birth, but he left his mark on the city along with others like Charles Bulfinch or Paul Revere. Born in Hartford, Connecticut, his talent came to him in unorthodox ways. His father was a dry goods merchant, and his mother died before he reached age four. His family took frequent vacations to scenic places in New England and New York, and perhaps his love for the look of outdoor places stemmed from that.

His education was rather piecemeal. He wanted to go to Yale, but an illness sidelined him. Instead, he lived and studied with a civil engineer at Phillips Andover and in three years added another piece of solid footing to a career he didn't know he would have. For a while he became a farmer, but not an ordinary plowman. He took classes

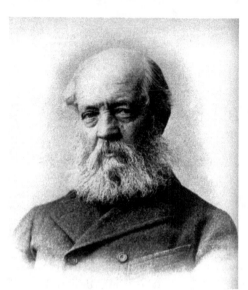

Frederick W. Olmsted.

at Yale in chemistry and scientific farming and won prizes for some of his farm products. He also redesigned his farmland and buildings according to principles of civic engineering.

Subsequently, he traveled through England visiting and drawing inspiration from some of the great estates, public parks and especially from a planned suburb of Liverpool called Birkenhead. On his return home, he gained fame as a writer and publisher. Olmsted somehow weaved together the pieces of his background, or education if it can loosely be called that, to become a major contributor to and early practitioner of the art of landscape gardening.

His singular achievement in designing Central Park in New York with partner Calvert Vaux made his reputation as a landscaper architect and gave him valuable experience in that part of civic planning. This park provided distinct challenges. It was rectangular in shape and had few natural features except for two large reservoirs. The traffic through it would be of many types—horse-drawn, pedestrian and vehicular. These certainly were not conducive to sylvan, pastoral scenes, but Olmsted and Vaux managed to hide large sections of the roads and to have paths and roads cross one another only when necessary and for the most part at different elevations. All of that had taken planning and imagination.

Olmsted conceived of parks as a way to relieve the sameness of city dwelling and a means of renewal, so he came up with ways to hide the city from within the park by using trees and other plant life. During the nineteenth century (in which he worked), his border planting of trees

hid much of the Manhattan skyline from within the park. The curving roads made the area seem larger than it was and provided a constantly changing variety of views.

Olmsted's own view was that public parks had to be accessible to all of the public, and he had some disagreements with city officials on that score during his work on Central Park. Following that, he and Vaux went on to design Prospect Park in 1865 for what was then the city of Brooklyn. Prospect Park, along with Central Park and Franklin Park in Boston, make the "top three" list of Olmsted's best-designed parks of the many he did, on the lists of most experts.

Frederick Law Olmsted believed that a park should be an integral part of a city, not just an ornament. His strong views would make for some rocky times in dealing with various communities, and that would happen in Boston as well.

For years, there had been a desire among Bostonians to create a park system and a number of public hearings had been held to garner ideas. These ideas and plans were far ranging, and most of them combined properties in Boston with areas outside the city limits. Besides the obvious problems that would have brought from jurisdictional disputes, all the ideas were too costly. Finally, in 1875, a three-member Park Commission was formed. From time to time, the commission consulted with Olmsted to ask him for ideas, but he and they were slow to come to an agreement. It has been speculated that this was a typical Boston thing. Olmsted was an outsider. In fact, he was most associated with New York. So there was local pride and also Boston conservatism working against having him come on board.

The commission wanted to build a park on the one hundred acres of the "Full Basin," the uppermost reservoir that had been created by building the millpond. Part of the problem was the need to reduce flooding and pollution. So, given the local pride and enthusiasm that kept them from making the logical choice, a contest was held that Olmsted did not enter. But even though they picked a winner, the commissioners decided not to use the winning design and turned to Olmsted at last and asked him to do a study on the Back Bay Fens.

On October 24, 1878, he and his son, John Charles Olmsted, submitted a plan for the Back Bay Fens. Olmsted met with Joseph P. Davis, the city

engineer, and with the superintendent of sewers. Davis and his department wanted to build a masonry storage dam for the overflow of Muddy River, but it would have been unattractive and costly.

Olmsted's idea was to build a salt marsh park, and in January 1880, his report, *Proposed Improvement of Back Bay*, was published. It provided sanitary improvement with a storage basin for the overflow from Stony Brook, and it restored the salt marsh.

The plan included conduits out to the Charles River from both the Muddy River and Stony Brook. The flow of salt water in and out would be regulated, and the plan provided for streets on both sides of the brook, the Fenway and Park Drive, with bridges between them. In the marshy area, Olmsted would plant the kind of grasses that could survive in seawater. Finally, the area would be called the "Back Bay Fens."

To understand the problem, it's necessary to understand the geography. Two inlets fed the Back Bay Fens: the Muddy River and Stony Brook. They approached the Fens from different directions, though they ran close together as they wound their way through Jamaica Plain. If you look at a current-day map, you'll see that the Muddy River runs in a curving course from Jamaica Plain to the area now known as the Fenway and then empties into the Charles at a place called Charlesgate.

Stony Brook had been more troublesome. Over the years, it had cost the city $3.5 million for flood control and had caused the city's worst flood of all time in 1867. Stony Brook began in Hyde Park at Turtle Pond, ran through Stony Brook Reservation in West Roxbury, through the area of the Arnold Arboretum in Roslindale and along the route of the present Southwest Corridor from Forest Hills to Roxbury Crossing and into the Back Bay.

Much of Stony Brook had been run into culverts or walled channels, but flooding persisted until improved culverts were built from near Roxbury Crossing to Parker Street, crossing under Huntington Avenue and running between the present Museum of Fine Arts and Forsyth Dental Clinic to Muddy River. (Two stone buildings that remain behind the museum contain valves.) In the other direction, flooding was controlled by channels that contained the brook from Roxbury southwest to Forest Hills.

Olmsted planned a sewer to intercept the water from Stony Brook at its gatehouses and deposit it in the Charles River. That was completed in 1881. In 1882, a conduit was also made for the Muddy River. It was 3,300 feet long and 11 feet high when completed.

Boston was getting much more than it expected. As we have seen, the city engineer had wanted to place a storage basin made of masonry in the park,

The Green Ribbon

but Olmsted argued instead for building a salt marsh in the Fens that would help in flood control and provide an aesthetic dimension to this park that would lie within an urban setting. The Fens had always been a wild terrain. It was no ordinary swamp or marsh, and certainly no greenery. It had pools and mudflats, marshes that were fully visible and some that were mostly submerged. Much of the sod was spongy and would always be so. His views prevailed.

Olmsted didn't expect or want the waters of the Fens to be used by visitors. He wanted people to stay on the walks atop the banks. He placed plantings between the walks and the water to act as a kind of "fence." He said, "The water in the basin will then have the general aspect of a salt creek, passing with a meandering course, for the most part, through or along the border of a sea-side meadow but will not be subject to fall with the tide, so far as to exhibit the disagreeable aspect which is natural in tide-basins."

Many things about Olmsted's work deserved exclamation points. This was one of them. Putting a salt marsh inside a city would be novel indeed, and the idea certainly caused a lot of talk. But Olmsted pointed out that the marsh was appropriate because of the original and current conditions. The plan proposed by Olmsted would look rather like the original landscape. But it would be a living system, and it would take a lot of thought and a lot of work before it would look good enough to be part of a park system. For it would be that—part of Olmsted's "Emerald Necklace."

Olmsted himself called it the "Green Ribbon." It would be a chain of parks and green spaces, some of them quite small, that would curve west and southwest out of Boston from the Common to Jamaica Pond, the Arnold Arboretum and Franklin Park in Roxbury. It would be a unique "linear park," seven miles in length, when finished. Three of the links already existed: the Boston Common, the Public Garden and Commonwealth Avenue Mall. In the original plan, Franklin Park would be connected by greenway eastward to the Atlantic Ocean in South Boston, but that did not eventuate.

In places where they didn't have room to build parks to connect with the other parks, he made roads into parkways, widening them and adding leafy trees. The chain of greenery took on the name "Emerald Necklace" and kept it. It remains a model of urban landscape design.

But the immediate problem for Olmsted was the park at the Back Bay Fens, and it was a difficult one. He had to find a way to restore the marshland while at the same time turning it into a presentable recreational area. He wanted to turn an evil-smelling swamp into a riverway with wooded shores and a winding watercourse. He worked on the sanitation problem with city engineers and also on restoring the area to its original salt marsh state.

John C. Olmsted, nephew of the landscape architect, took on a portion of the project in 1881 with a plan for Muddy River Improvement. The stream would be given gentle turns and curves. Its swamp of cattails would be changed to a large pond (Leverett Pond) and connected to Ward's Pond. The plan also included parkways, bridle paths and walking trails. This part of the work began in 1890, and the part that includes Leverett Pond, Willow Pond and Ward's Pond was, together, called "Olmsted Park" in honor of the designer.

The reconstruction of this area would do two separate things. In some parts of the 130 acres, he would have to dredge, while in others he would need to fill. It wasn't just a question of dumping soil and smoothing it out. Olmsted laid out a plan that first required grading the land to the contours that he specified. Derricks had to be specially made and floated out onto the marsh to dig and fill, with some of the fill actually being provided by people's garbage.

In 1888, what was dubbed the Commissioners Channel was constructed, much deeper than the previous channel, from the Fens basin, up Huntington Avenue through Parker Street alongside the Providence Railroad. The overflow chamber served as the dry weather overflow that had previously gone into the old conduit. Only the excess went into the Commissioners Channel. In 1897, the old conduit was disconnected from the system, since which time the Commissioners Channel has carried all storm flow.

It took until 1895 to complete everything, and when it was done, it was flushed twice a day by brackish tidewater. However, in 1910, a dam was built near the mouth of the Charles, and that turned the Fens into a freshwater area. With the completion of this park, the area no longer flooded but took the overflow from Muddy River and Stony Brook, as well as overflows from sewers and storm drains, and deposited it safely in the Charles.

In 1895, a large tract in the center of the Fens land was appropriated for the Museum of Fine Arts, with Huntington Avenue in front and the Riverway in the back. When that splendid building was in place, it had the effect of changing the perception of the Fens from a landscape to a scenic backdrop for the man-made structures that surrounded it, and less a recreational area than a visual one.

Today, the borders of the park have town houses, apartment buildings and cultural institutions like the Museum of Fine Arts, the Isabella Stewart Gardner Museum, the Massachusetts Historical Society and colleges such as Simmons, Emmanuel, Northeastern and Wheelock. The Boston Red Sox make their home a few blocks away. Their ballpark, built in 1912, was

The Green Ribbon

The Fenway.

named Fenway Park for the area in which it is located. Basketball courts and athletic fields, including a small stadium used for school football, were built as well. There are also statues and memorials, including a Memorial Rose Garden and a victory garden that was created in 1911.

The Fens today allows leisurely walking and country-like beauty along the streams within view of the city skyline. It is part of the park system that Bostonians came to call the "Emerald Necklace." This system was being constructed at the same time that the Fens park was worked on.

A major "jewel" in the chain would be the Arnold Arboretum. This collection of shrubs and trees was established in 1872 from the will of James Arnold, a New Bedford whaling merchant. The collection came from all over the world, and Charles Sprague Sargent was appointed director. He was a good fundraiser but needed help in setting out and maintaining the collection. He turned to Olmsted. At first, Olmsted worried about having it serve as both a park and an arboretum. It would have to be used as a botanical "laboratory" as well as a recreational spot. But he accepted the challenge and drew up a preliminary plan in 1878. Sprague was known as a difficult person, though a hard worker, but Olmsted managed to get along with him and deferred to Sprague on most botanical planning.

Olmsted and Sprague, after four years of effort, convinced the park commission to allow the Arnold Arboretum to become part of the park system. In 1882, an agreement was signed between Harvard University and the City of Boston, by which the city would own the land and lease

Arnold
Arboretum.

it to Harvard for a dollar a year for one thousand years. The Arboretum became a 265-acre jewel in the Emerald Necklace, with construction beginning in 1883.

To Olmsted, Franklin Park was the most important part of the park system. It included twelve small farms and their houses and required land taking by eminent domain with some litigation and much cost. It was called West Roxbury Park and was later changed to Franklin Park in hopes of getting funded by the bequest of Benjamin Franklin to the City of Boston. (The funding never came.) To Olmsted, this was the most important jewel in the chain because of its five-hundred-plus acres of land that included many natural topographical features.

The Green Ribbon

Olmsted admired the setting and said this:

The all-important feature of the West Roxbury site is a gentle valley nearly a mile in length and of an average breadth between the steepest slopes of the bordering hills of less than a quarter of a mile. Relieved of a few houses, causeways, and fences, left with unbroken surface of turf and secluded by woods on the hillsides, this would at once supply a singularly complete and perfect though limited example of a type of scenery which is perhaps the most soothing in its influence on mankind of any presented by nature.

In his laying out of Franklin Park, Olmsted was able to provide an illusion that a visitor was walking in a rural setting far from any houses or buildings. The only distant views were of the Blue Hills and the Arnold Arboretum, so the viewer had the feeling of isolation that was in keeping with Olmsted's philosophy that a park should be pastoral rather than picturesque and should be tranquil and restorative of the spirit for city dwellers.

In Olmsted's original Franklin Park, a city dweller would have felt alone with nature and far from the cares of city life. As time progressed, however, the pristine vision of his park was eroded. Franklin Park was not used according to his plan or philosophy. The city kept allowing encroachments, such as a golf course, a zoo, a stadium and even a hospital.

Franklin Park.

The last two parts of the Emerald Necklace to be completed were the improvement of Muddy River and Jamaica Park. For years, the Muddy River was a rather harmless but unattractive stream. The town of Brookline itself was even called "Muddy River." But as time went on, population grew and so did pollution and flooding. The river became a source of mosquitoes and disease, and the area on both sides near the present Huntington Avenue and Brookline Village became shoddy and slum-like.

In 1880, Brookline formed a Park Commission and gave it the authority to work with Boston to plan a park that would lie in both communities. The nearly dictatorial leader of the Brookline Park Commission was the same Charles Sargent who had worked with Olmsted on the Arboretum. Here, they often clashed.

These projects took a long time because it was difficult and costly to get the land. Some people owned land on both sides of the potential parkland (in both communities), and besides, Boston was having money problems at that time. "General Plan for the Sanitary Improvement of Muddy River" was drawn up but altered in 1890 by the Olmsted firm, with changes in the Leverett Park area. The plan covers the area from where the Riverway meets Brookline Avenue to Leverett Pond.

Along the lower stretch, the Muddy River intersects five hundred acres of land purchased by David Sears II. That five hundred acres includes Cottage Farm along the Charles River, where a skirmish took place during the Revolution, and extends south of Muddy River into today's Longwood

Christ Church, Longwood.

The Green Ribbon

Medical area. Sears built country estates in his Longwood neighborhood, so named for Napoleon's estate on St. Helena. He also built Christ Church, which became a landmark in the Longwood area.

Several changes made more recently will also serve as landmarks for today's readers. A stone overpass near South Huntington Avenue carries Route 1 (the Jamaicaway) over Huntington Avenue and is visible from Brookline. Another landmark is today called the "Landmark Center." In 1929, Sears, Roebuck built a two-hundred-foot tower, with its parking lot covering the link between the Back Bay Fens and the Riverway. A ball field was also built on the meadow near Leverett Park.

The only large freshwater pond within city limits is Jamaica Pond. The park commissioners and Olmsted wanted to make it part of the Emerald Necklace. Icehouses that had been built on the pond and contaminated the water were removed in the 1870s. Olmsted viewed the pond as "a natural sheet of water, with quiet, graceful shores, rear banks of varied elevation and contour, for the most part shaded by a fine natural forest-growth to be brought out over-hanging, and darkening the water's edge and favoring great beauty in reflections and flickering half-lights."

Before it could be acquired, the city had to take land around the pond by eminent domain, since it was a popular area for large summer homes owned by the wealthy, including Governor John Hancock, historian Francis Parkman and James Perkins, brother of Thomas Handasyd Perkins, who built Pinebank. Two other homes by this name were built, the last of them designed by the firm that also designed the Museum of Fine Arts. Pinebank was demolished in 2007. Only one other house remained on the edge of the pond. Some of the small houses were kept and used as places to get refreshments. Fortunately, Olmsted did not have to make many changes, and the pond and its surroundings remain largely as he designed it.

As to the parkways that connect the various links in the Necklace, in Olmsted's view it was all one parkway. But various names were given to different parts. The outer edge of the Back Bay Fens near the Museum of Fine Arts, the Gardner Museum and Simmons and Emmanuel Colleges was called "The Fenway." On the other side of Muddy River near Schoolboy Stadium and extending through Longwood to Huntington Avenue, the street was called "The Riverway." That same road, extending south to Jamaica Pond, was called "The Jamaicaway," and from there to Forest Hills and Franklin Park, it was known as "The Arborway."

As originally planned, the Emerald Necklace was to extend from Franklin Park at Blue Hill Avenue down a widened Columbia Road to the Dorchesterway and Strandway in South Boston and on to Marine Park

and Castle Island. Columbia Road already had a lot of housing, and it had a strip down the center for streetcars. It could not be widened or made green. The Dorchesterway and Strandway are now Day Boulevard. Castle Island belonged to the U.S. government, and it wasn't until the 1920s that a causeway from there to City Point was built.

Olmsted modified some of the parts of the necklace that he had not designed, such as Boston Common, the Public Garden, the Commonwealth Avenue Mall and some green spaces between the parks. With great skill and creativity, Frederick Law Olmsted had succeeded in encircling Boston with a living, invigorating "green ribbon."

CHAPTER 8

FROM COMMERCE
TO CULTURE

*I must study Politics and War, that my sons may have liberty to study
Mathematics and Philosophy. My sons ought to study Mathematics and
Philosophy, Geography, Natural History and Naval Architecture, Navigation,
Commerce and Agriculture, in order to give their children the right to study
Painting, Poetry, Music, Architecture, Statuary, Tapestry and Porcelaine.*
—*John Adams*

Adams was speaking for himself and his family, but in a larger sense he was
describing the strivings and accomplishments that could and would be
the heritage of his city and state. After his generation had dismissed the British
from Boston, they established their city as a wealthy one, built its industry
based on new inventions such as steam power and built its infrastructure with
filled-in land, adding new streets and erecting new buildings. Then they turned
to humanitarian reform—chief of which was abolitionism—and also to a
cultural improvement that matched the "Painting, Poetry, Music, Architecture,
Statuary, Tapestry and Porcelaine" that Adams had said they might aspire to.

So in addition to its top position as a hotbed of abolitionism, Boston also
led the North as a center of intellectual and cultural pursuits. It could boast
several of the country's top writers and poets—people like Thoreau and
Emerson, the Alcotts and John Greenleaf Whittier, plus many other of the
biggest names in literature from the nineteenth century. They all knew one
another and frequently gathered together. They tended to espouse liberal
causes, especially freedom from slavery—a pursuit they believed to be not
only wrongheaded but evil as well.

Many of the writers lived on Beacon Hill. Richard Henry Dana, when he finished two years at Harvard, spent an additional two sailing around the Horn to California, keeping a journal and writing *Two Years Before the Mast* in 1840, a book that became an American classic. William H. Prescott, son of the hero of Bunker Hill, became one of the greatest American historians.

The period following the War of 1812 is known as the "Flowering of New England," its greatest period of intellectual and literary outpouring. "As a literary centre Boston was long supreme in the United States and still disputes the palm with New York," said *Baedeker's United States* (1893). Bret Harte said it more plainly and in a folksy style. He said that in Boston "it was impossible to fire a revolver without bringing down the author of a two-volume work."

A visitor would have had a wide range of targets, intentionally or not. Besides being the era of Emerson and Thoreau, it was that of Henry Wadsworth Longfellow, who lived for a time on the hill but, after his wedding to Fanny Appleton (daughter of Nathaniel), purchased the Craigie House in Cambridge, where Washington had stayed during his time in Boston.

Nathaniel Hawthorne, who lived in Salem and wrote tellingly of the Puritan days in *The Scarlet Letter* and *The House of Seven Gables*, married the youngest of the three Peabody Sisters of Boston, Sophie. The second sister, Mary, married educator Horace Mann, and the eldest, Elizabeth, worked for William Ellery Channing, taught for Bronson Alcott, founded America's first kindergarten and was the confidante of painter Washington Allston.

Elizabeth founded the *Dial* magazine at her bookshop on West Street. In it, she published Hawthorne's work, and the magazine was edited by feminist Margaret Fuller and Emerson. Hawthorne also wrote a novel based on his experiences at the Brook Farm utopian community, its protagonist widely believed to be based on feminist Margaret Fuller.

Beacon Hill also boasted Dr. Oliver Wendell Holmes, who wrote a poem, "Old Ironsides," that may have saved the ship from the scrap heap. Holmes became known as "The Autocrat of the Breakfast Table." He thought of America as a breakfast table in a boardinghouse where he, as a doctor, sat at the head and expounded on his current thought in conversations with other boarders. He wrote regularly in that vein, producing sketches for the *Atlantic Monthly* and then publishing them collectively in several volumes.

Perhaps the "Saturday Club," as much as anything, gave evidence of Boston's position as the premier site of literary thought in America. The Saturday Club was an incredible all-star group of writers, poets and publishers who gathered at the Parker House (the hotel where Boston

cream pie was invented) and discussed literary matters, much as other writers and thinkers had in the coffeehouses of other times and places. Most of them were Bostonians, and they typically met on Saturdays for stimulating conversation and the sharing of ideas and philosophies. They included Holmes, Hawthorne, Dana, Lowell, Fields, Howell, Emerson, Thoreau, Whittier, Parkman, Longfellow, Fields and sometimes Charles Dickens and others.

One of Holmes's essays from the *Atlantic Monthly* was about the Saturday Club and includes contemporaneous author's notes in which he writes about the club:

> *The Saturday Club was founded, or, rather, found itself in existence, without any organization, almost without parentage. It was natural enough that such men as Emerson, Longfellow, Agassiz, Peirce, with Hawthorne, Motley, Sumner, when within reach, and others who would be good company for them, should meet and dine together once in a while, as they did, in point of fact every month...The club deserves being remembered for having no constitution or by-laws, for making no speeches, reading no papers, observing no ceremonies, coming and going at will without remark, and acting out, though it did not proclaim the motto, "Shall I not take mine ease in mine inn?" There was and is nothing of the Bohemian element about this club, but it has had many good times and not a little good talking.*

He continues:

> *The Saturday Club met from 1855 on the fourth Saturday of each month, at the Parker House hotel, on Tremont Street, Boston. Originally it was formed from those around the* Atlantic Monthly *magazine, of which Holmes and James T. Fields were original editors. (The Old Corner Bookstore down School Street from the Parker House was the first office of the Ticknor and Fields publishing company, which moved to Park Street when it became Houghton Mifflin and Company.) A literary club by the same name still meets, at the Boston Athenaeum, nearby.*

Notwithstanding its reputation as a cultural center, one dark spot clouded Boston's reputation for free intellectual thought beginning in the late nineteenth century. City officials could ban anything they believed to be immoral, salacious or offesnive. That included books or plays. The words "Banned in Boston" cast Boston in a bad light in more sophisticated places,

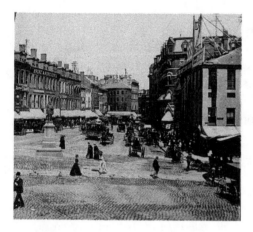

Scollay Square.

and in fact, the phrase often helped a banned play or work in these other places and might even be included in the advertising.

Despite its Puritan heritage and these later atavistic practices, theatre existed in the town, first disguised as something else, but later theatres such as the Tremont flourished. The theatre district ran along Washington Street from West Street to Boylston as well as on Tremont Street.

From the 1880s to about 1920, the most popular entertainment in America was vaudeville. It was live entertainment made up of singers, dancers, comedians, even plate spinners, jugglers and dog acts. Boston got into the act in 1883 when its first vaudeville theatre opened. Its last one outlasted vaudeville but continued with entertainment of an unsavory sort. It was the Old Howard, and it lasted until 1953; its Scollay Square location was a favorite among sailors and young men out on the town.

Boston had a number of fine painters in the nineteenth century, though it may better be recognized for its appreciation of art than for its production. One who did produce artwork was the lithographer Louis Prang who lived and worked in Roxbury. He perfected a process for reproducing art prints but is especially known as the "Father of the American Christmas Card." He had been making such cards in England but did his first American card in 1874. Prang also produced books for art education and made watercolors that were used in classrooms for years.

John Singleton Copley has been mentioned as an outstanding portrait painter who spent much of his time in England. In a way, Copley belongs to both Beacon Hill, where his land was used for all those brick houses, and the Back Bay, where his name graces the square outside the museum where so much of his work is hung.

John Singer Sargent's work is there too. His haunting interior, *The Daughters of Edwin Darley Boit*, hangs in the Museum of Fine Arts, where it draws a lot of attention. His *Portrait of Madame X* scandalized Paris and sent him to London. He made trips back to Boston, during one of which he painted a portrait of Isabella Stewart Gardner that was risqué for its day.

From Commerce to Culture

Prang Factory, Roxbury.

Copley Square.

Sargent's *The Daughters of Edwin Darley Boit.*

Most of Gilbert Stuart's work can be seen in Boston museums, though he, too, spent a fair amount of time in England. Many Bostonians sponsored him, but he is perhaps best known for his portrait of Washington on the dollar bill and for the one saved courageously by Dolley Madison when the British invaded Washington and burned the Executive Mansion. Stuart spent his final days in Boston and did many portraits but died a pauper.

Individual Bostonians began to study painting. Many ladies used pastels and painted china, while painters like Albert McNeill Whistler and Winslow Homer gained fame after the Civil War. Whistler, from Lowell, is best known for his portrait of his mother, usually referred to as *Whistler's Mother.* This happened because of a happy turn of luck. One day, a model Whistler had engaged did not show up. His mother subsequently posed for this near-monochrome, and it turned out to be his best work.

Homer's first illustration appeared on June 13, 1857, in a Boston magazine called *Ballou's Pictorial.* The same year, *Harper's Weekly*, then a new magazine, published more of his work. His prints in *Harper's* continued into the 1870s.

Among the other painters of that era was Washington Allston, who also spent time in England, but the latter part of his life was spent in Cambridge. Allston had a great influence on American landscape painting. He also drew

many themes from Biblical stories. His apprentice, Samuel F.B. Morse, best known for inventing the telegraph, was also an accomplished painter. Morse did portraits of John Adams and Lafayette.

Another post–Civil War artist was sculptor Daniel Chester French, who did the *Minute Man* in his hometown of Concord at the North Bridge. (The one at Lexington Battle Green was sculpted by another person and differs in being a militiaman rather than a farmer who went to battle.) French later sculpted the bronze doors to the Boston Public Library, the statue representing John Harvard in Harvard Yard, that of Abraham Lincoln at the Lincoln Memorial and a statue of John Boyle O'Reilly at Boylston Street and Westland Avenue in the Fenway.

The famed sculptor Augustus Saint-Gaudens did the *Shaw Memorial* opposite the State House commemorating the all-black Fifty-fourth Regiment and its leader, Robert Gould Shaw. Once it was commissioned, the sculptor worked long and carefully on this raised relief for thirteen years to attain authenticity and grandeur. It is incredibly lifelike, and though it shows a group, it still pays close attention to the individual figures. It faces the State House on Beacon Street.

When the Back Bay had been laid out, its plots sold and built up with housing, it came time to act on some of these cultural impulses and establish institutions that would enhance Boston's growth as a major world cultural center. The natural place to do this was the Back Bay. It had room for these things and was where many of the wealthy people lived—those who were likely to make use of the new institutions.

I like to think of this establishment of cultural institutions as the building of a kind of "cultural infrastructure" in Boston, and particularly the Back Bay. These institutions were of several types and were complemented elsewhere in Boston and its surroundings by those of other types, such as medical facilities that reflected the eminence of Boston in that significant area.

Most noticeable, perhaps, are the museums that appeared in the nineteenth century and remain important to this day. The Museum of Fine Arts, now recognized as one of the world's best, has achieved what Bostonians of that era hoped it would. Its first home was in Copley Square on the south side, where the Copley Plaza Hotel would later rise.

The museum was created in 1870, much of its early collection coming from the art gallery of the Boston Athenaeum. The Gothic Revival building, designed by the firm of Sturgis and Brigham, had its grand opening on July 4, 1876—the 200th anniversary of the birth of the nation. It was a brick building that used a great amount of terra cotta.

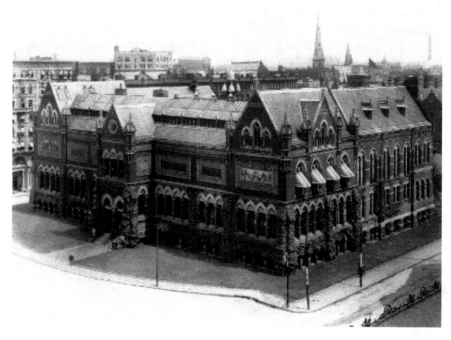

Museum of Fine Arts at Copley Square.

Boston's appreciation of the arts was at once apparent, and the "MFA," as it is often called these days, became quite popular, so much so that its expanding collections outgrew the building, mostly because of generous donations from Bostonians. Although it expanded its space twice in Copley Square, that wasn't enough. In 1899, twelve acres of land were purchased on Huntington Avenue, and the Guy Lowell design became a new building in 1909.

Moving all those fabulous collections became a monumental task, and also a delicate one, because 110,000 objects of art had to be transported by horse-drawn wagons over roads that were bumpy and rutted. In addition to its outstanding pieces and exquisite settings, the museum also became known for its museum school.

Just down the Fenway from the MFA's 1909 building is the Gardner Museum—sort of a next-door neighbor. It's a truly unique building, and it reflects its truly unique founder.

If the movement toward acculturation of Boston could have been encapsulated in one person (and perhaps it was), that person would have been Isabella Stewart Gardner. Not only was she a devotee of most of the fine arts and an exemplar among their adherents, but she also built a pleasure palace for their enjoyment and made it fashionable and desirable for other Bostonians to join her in those pursuits.

She liked to dance, sing, engage in conversation with both women and men—with whom she also liked to flirt—and to stand at the center of attention. She was supremely skilled at all of these.

The Boston society pages called her many names, including "Belle," "Donna Isabella," "Isabella of Boston" and "Mrs. Jack." Isabella offered frequent opportunities for the gossip tabloids of her day. Her behavior was unconventional, even Bohemian, and so were her tastes in style. Once, she rented a pair of lion cubs from a zoo and paraded down the street with them. Another time, she and her husband were late for an engagement and she was able to get the railroad to lend them a train for their personal use.

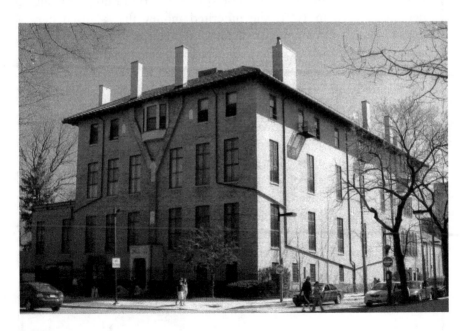

Gardner Museum.

She owned fast horses, drove fast cars and smoked. She was also, apparently, a Red Sox fan. In 1912, the year Fenway Park was built, she appeared at a very formal concert at Symphony Hall wearing a white headband that bore the words: "Oh, you Red Sox," nearly causing a riot, according to news reports.

Gardner came to all this from a surprising background. Neither she nor her family had been part of the original settlers or one of the Brahmins. Isabella came to Boston through marriage and then transcended Boston's standards with new and improved ones of her own. Born in New York, she was the granddaughter of a tavern owner. Her family prospered in commerce, but they were also descended from the English royal house of Stuart.

In 1860, she married Jack Gardner, Boston's most eligible bachelor. Their only son died within two years of his birth in 1863. Shortly afterward, she suffered a miscarriage and was warned to avoid further pregnancies. To battle her depression, her husband brought her to Europe, and she found that the way of life there, particularly in Italy, had a salutary effect on her both physically and psychologically.

Isabella traveled widely and is known to have admired a palazzo in Italy as well as many of the masterpieces of art in Europe. When her father died in 1891, she inherited money that allowed her to become a collector of art of all kinds. Her collecting became somewhat of a sport as well as an avocation. She loved to hunt for and find, purchase and exhibit some of the world's greatest art. She would invite prestigious viewers and critics to her exhibitions. Highly motivated to learn more about art, she studied art by reading, visiting studios, traveling and studying at Harvard with art historian Charles Eliot Norton.

After that she pursued other interests—with abandon. She also shrugged off the role of a proper Boston woman—a decoration on the arm of her husband—and did pretty much whatever pleased her from that point on. What pleased her most was collecting artwork and sharing her love for the fine and decorative arts.

Isabella can be considered a precursor to today's woman, at least as far as was possible in her day. (To grasp the significance of history and even of biography, we need to think about the relationship of a person to her or his *time*, not just to the overall history of the world.)

Isabella provided a total do-over for nineteenth-century Boston, captivating the media of her time and showing the way for those who followed.

She counted among her friends artists, composers, poets, writers—people whose ideas and conversation would stimulate her and others. She was a close friend to John Singer Sargent, Henry James, George Santayana and Julia Ward Howe, to name a few.

Beyond that, she often socialized with members of groups who had been shunned elsewhere. She was able to associate closely with blacks, Jews, gays, foreigners and people of every strata, using her unique set of talents—brilliant social skills and a talent for publicity, some of it favorable. She was intelligent, well-educated, was able to take a wide vision of her time and milieu and was also charming, witty and poised. She used these talents to create a cultural society that was not only local but international as well, and she at the social center of it.

Her friendship with gay men probably stemmed from an incident in her own life. Her husband, Jack, had a brother who had committed suicide, leaving three teenage sons. She and Jack Gardner then adopted the three boys. The oldest was gay, and he too committed suicide, probably because of a failed love for another man. From that may have arisen her sympathy for those of homosexual persuasion. In addition to gays, Gardner also entertained other students of the arts, intellectuals and supporters of women's rights.

By bringing artistic and intellectual people together and by elevating the acceptance and patronage of the arts, she became a major factor in making Boston a center for the arts. She not only collected art but was glad to have it seen and admired as well.

"Many came with 'grave doubts,' many came to scoff, but all wallowed at her feet," she gloated to the connoisseur Bernard Berenson, who was her adviser and purchasing agent.

When her husband, Jack Gardner, died in 1898, she set about to build what would become a monument to her skill in collecting art, a building that would also embrace her singular way of looking at things. She called it Fenway Court, and its architect designed it after a fifteenth-century Venetian palazzo. Isabella became involved in all of the planning and building but especially in the placement of her

vast collection of art that it would house. Her collection spans thirty centuries and has all kinds of art, from rare books and manuscripts to works of the masters, especially those from the Italian Renaissance.

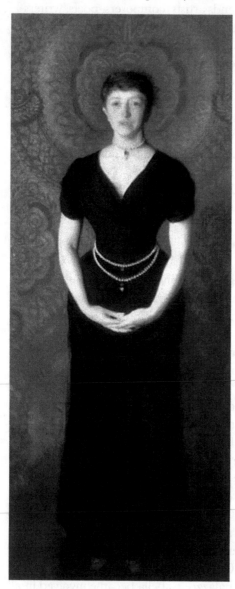

The building has an interior garden in a courtyard that has a roof of glass. During her time and afterward, it was used to hold soirees, concerts and plays. Before it was built, Gardner used her Beacon Street home as a salon to bring together artists, works of art and groups of people who wanted to discuss ideas. Later, the palace served those functions.

Like its creator, the collection and its arrangement could never be said to be conventional. The way she arranged her objets d'art was decidedly eclectic. She meant the pieces to be integral parts of informal, intimate settings, so they aren't displayed as they would have been in most museums, neither chronologically nor by style. Isabella lived in her "palace" in an apartment on the fourth floor and frequently entertained. She "opened" the building with a New Year's Night gala in 1903.

Isabella Stewart Gardner.

She intended it to endure long after she had gone, but she wanted it to remain true to her vision, so she laid out each detail, specifying that it must remain as it was, and had that codified in her will. She also left an endowment for its future upkeep. According to her directions, nothing could be sold or moved, nothing added or taken away.

All remained as she planned it until thieves made off with some of the best pieces on March 18, 1990. They have yet to be recovered. The burglars picked select pieces, estimated at about $250 million in value, making it the largest art theft in the world. Sadly, the theft has crowded out the marvelous story of "Mrs. Jack" so that mention of her name often recalls the theft rather than her gifts to Boston. Her story is far more worthy of our attention.

When she died in 1924, the occasion was marked in ways befitting her extraordinary life. Not one but two funerals were held, a private one in the Spanish chapel of her palace and a public one in the Church of the Advent. Afterward, her body was covered with a purple pall and was returned to the palace to lie in state under a huge crucifix between tall candlesticks. For four days, nuns prayed over her, rotating tours of duty day and night.

She has been the subject of two biographies and many articles. If she were alive today, Gardner's rather plain face would no doubt frequently grace the society pages of the *Boston Globe*, but more symbolically, her quite stylish and even "outré" habiliment would frequent the covers and pages of style, fashion and popular culture magazines. But these days are not those ones—far from it. She would make a fascinating subject for a biopic, but there's also plenty of room for a fantastic fictionalized flick.

Another unique building that is quite like a museum is the Boston Public Library, which certainly has outstanding art pieces. Sargent's murals on the third floor, *The History of Religion*, are perhaps the best known, but many others stand out, including Edwin Abbey's *Quest of the Holy Grail* panels and the aforementioned doors by French.

The idea for a library was presented in 1826 by George Ticknor, Harvard professor of languages. It was built after many years and several large

contributions by people like Mayor Quincy, Edward Everett and mainly from Joshua Bates, the head of Barings Bank in London who came from Weymouth, Massachusetts.

The first library occupied an old house on Mason Street in 1854. It moved then to an Italianate-style building on Boylston Street between Park Square and Tremont Street and then to Copley Square. The present Renaissance-style building was designed by the architectural firm of McKim, Mead and White and was erected in 1895. When built, it stood longitudinally across Copley Square from Trinity Church, another architectural gem, next to the New Old South Church and at the time at right angles with the Museum of Fine Arts, all excellent buildings.

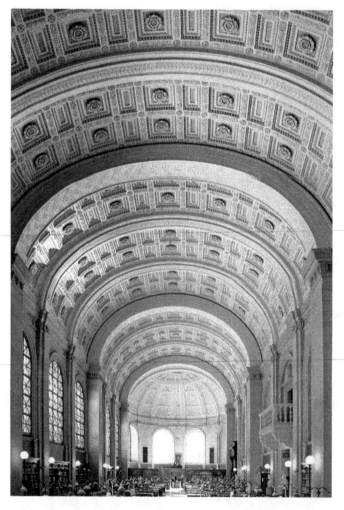

Bates Hall, Boston Public Library.

From Commerce to Culture

Bates Hall, named for Joshua Bates, takes up the full length of the second floor. With its vaulted ceiling, it is the largest reading room of its type and recalls a cathedral as much as anything else. Called the "Palace of the People," the library has a courtyard with an arcade that looks like a Renaissance cloister.

Architecture certainly struck some high notes in Boston's first Golden Age. We know of Bulfinch, of course. But we also had Asher Benjamin, who came to Boston from western Massachusetts. He was also an author who wrote seven handbooks on design that were used by builders all over America for improved structures, some of them in Federal or Greek Revival style, as espoused by Benjamin. He designed a number of Boston churches that still stand and helped to design the venerable Quincy Market.

Stained-glass window, Trinity Church.

New Old South
Church.

Boston was also lucky to have Henry Hobson Richardson, who designed one of the outstanding structures in the country, Trinity Church in Copley Square. This Romanesque church, with its clay roof, multicolored rough-hewn stone, heavy arches and tower, was copied in other parts of the world as well. Inside are 21,500 square feet of extensive murals, all by American artists, as well as stunning stained-glass windows. In 1885, the American Institute for Architecture named it the most important building in America, and it remains on its top ten list.

In addition to these citadels of culture, we had the Boston Athenaeum on Beacon Street and several churches, such as Arlington Street Church and the New Old South at Boylston and Dartmouth, which had moved its congregation from the meetinghouse at Washington and Milk Streets of historic note. Built in 1875, the campanile or bell tower slowly began to

From Commerce to Culture

Trinity Church.

lean to one side and had to be replaced in 1920. It provided an example of what can happen when those piles that underpin buildings in Back Bay are insufficient as footings for large buildings. New Old South was the only Congregationalist church based on the Trinity to survive the onslaught of Unitarianism. The building, built of Roxbury puddingstone with Moorish arches, is an easily identified cornerstone of Copley Square.

A few blocks east and a block north, at the corner of Clarendon, is the First Baptist Church. The angels with trumpets at the top sometimes give it the name the "Church of the Holy Beanblowers." Those "bean-blowers" were carved by Frederic Bartholdi, known better for sculpting Lady Liberty on the Statue of Liberty. At the time, Bartholdi was angry with New York, and he almost put the Statue of Liberty on an island in Boston Harbor.

CHAPTER 9

BUILDING THE GOLDEN AGE

At the time the Museum of Fine Arts was organized, its future home, Huntington Avenue, ran west out of Copley Square and parallel to the South End grid of streets. It was the only major street at the time laid out on the north side of the Boston and Providence Railroad tracks and would soon have the Boston and Albany rail yards on its other side separating it from Boylston Street and Back Bay proper, whose grid of north–south streets ran at a different angle than the South End streets.

Early in the decade of the 1870s, the Boston and Albany Railroad (formerly the Boston and Worcester) rail yard occupied the land between Boylston and Huntington, west of Exeter (present-day location of the finish line for the Boston Marathon) as far as Dalton (where the Sheraton Boston now stands). The presence of that rail yard had a major effect on future development because people didn't want to live next to a rail yard and because it placed a big barrier between the Back Bay and the South End. Neither Boylston Street nor Huntington Avenue seemed suitable for residential districts, at least not opulent ones. Both were slated for commercial development.

Huntington Avenue was basically a street without buildings. The first building erected was the Massachusetts Charitable Mechanic Association Hall, built in 1880 and known to future generations as Mechanics Hall. The association, formed in 1795 with Paul Revere as its first president, promoted the mechanical arts. The new building at the corner of West Newton Street would hold exhibits and conferences until it was razed to make room for the Prudential Center in 1962.

PERSPECTIVE VIEW OF MECHANICS' BUILDING.

Mechanics Hall, Huntington Avenue.

Following the placement of that important anchor, the avenue began to be built up, first with rows of walkup tenements that reached as far west as West Chester Park (later Massachusetts Avenue). Parallel to Huntington and next to the Boston and Providence tracks, another street of row houses was built on Saint Botolph Street (named after the patron saint of Boston, England).

When Back Bay filling was completed in the late 1880s, commercial development took hold. Services had to be provided for the new neighborhoods, and, being a capitalistic society, private enterprises filled the bill. The land along Boylston was relatively cheap and available, so that was used for mercantile purposes. Newbury Street, while residential, became a buffer zone between Boylston Street and the residential neighborhoods by providing upscale shopping of the kinds that would be appreciated by Back Bay patrons.

In effect, Newbury Street became an area of mixed use, with retail shops on the ground floor and residential on upper floors, so that residents had a gradual transition from the residential areas to the commercial ones to the south.

Infused within the Huntington Avenue commercial zone were some cultural institutions located, therefore, close at hand to the same patrons who might shop on Boylston or Newbury Streets. The Boston Symphony Orchestra (BSO) had shared space at the downtown Music Hall on Winter Street with dog shows and wrestling matches in a building that, not withstanding these noble uses, was due to be demolished in 1893, threatened by road building and the impending subway construction.

The architects who designed the nearby Boston Public Library undertook this challenging job as well, completing Symphony Hall in 1900. The acoustics were overseen by Harvard professor of physics Wallace Clement Sabine.

The building is modeled after a concert hall in Leipzig that was destroyed during the Second World War. Long and narrow, with stage walls that slope

inward to direct the sound, it is considered second only to the music hall in Vienna for excellent acoustics wherever you sit. It, too, has artwork, mainly its statuary of ten mythical and six historical Greek and Roman figures that reinforce the notion of Boston's role as the "Athens of America."

The only flaw is its siting next to strictly commercial buildings with a structure that nearly fills its lot, whereas the land on the opposite (northeast) corner might have been purchased to better advantage. That plot was bought instead by the Massachusetts Horticultural Society, which relocated from Tremont Street. The new building was its third. Horticultural Hall was built in 1901. Its opening was a ten-day affair, during which the building was filled with flowers from all over the world, including one thousand orchids, the finest floral gathering of its type until that time. The building was renovated in 1984 and sold to the neighboring Christian Science Church in 1992.

Other musical institutions followed Symphony Hall to the area. Chickering and Sons, which made pianos, built a place next to Horticulatural Hall. It later moved, and the building housed successive theatres. In 1902, the New England Consevatory of Music moved to the corner of Huntington and Gainsborough, near what would become, in 1911, the Boston Arena.

Of course, the Museum of Fine Arts moved in 1907 to its location a few blocks west of there, so Huntington Avenue became an arterial extension of Copley Square as the cultural heart of Golden Age Boston.

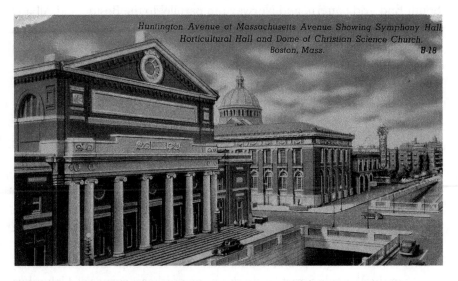

Symphony Hall and Horticultural Hall.

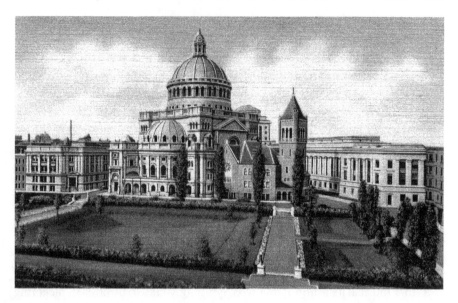

Christian Science Church.

In the same area that included Horticultural Hall, the Christian Science Church (later the Christian Science Center) rose. The church was established in 1886 by Mary Baker Eddy. The congregation bought a triangular piece of land just east of Massachusetts Avenue and set back a block from Huntington Avenue on Falmouth Street at Norway Street. These streets were part of the South End grid pattern, and Norway ran parallel to the Boston and Albany tracks. It was part of the area with three- and four-story apartments and a few town houses. The church was built in 1895, and its impressive dome was added in 1906. Today, the center has several fine buildings and a lot of open space around them, including a reflecting pool.

The Back Bay became the locus of many cultural and educational institutions in the second half of the nineteenth century. The Massachusetts Historical Society opened its handsome (seventh) building on Boylston Street near the Fenway in 1899, placing it within walking distance of the Christian Science Church and the location of the Museum of Fine Arts, which would be built eight years later.

As the century turned, Boston was one of the few American cities with two Major League baseball teams, and they played in parks on the opposite sides of a railroad line that separated the Back Bay from the South End. The older, National League Braves (earlier called the Red Caps and other names) played in the Walpole Street Grounds on the northeast corner of Columbus

Building the Golden Age

Above: Huntington Avenue grounds, 1903 World Series.

Right: Huntington Avenue American League baseball grounds.

Avenue and Walpole Street. The tracks of the old Boston and Providence Railroad had become those of the New York, New Haven and Hartford Railroad where the Southwest Corridor now runs.

Across the tracks on the Back Bay side, located where Northeastern University's Cabot Center now stands, was the Huntington Avenue Grounds, home of the Boston Americans with their great pitcher, Cy Young. It was the site of the first World Series game in 1903, and a plaque giving information on this has been placed at the location. The Boston team won the series from Pittsburgh, five games to three. In 1912, they moved to a new park a mile or so away called Fenway Park. They were, by then, the Boston Red Sox, and in their new field they won a second World Series from the New York Giants, also in eight games since one game was called because of darkness, ending in a tie.

Fenway Park.

In 1860, the Boston Society for Natural History moved from Mason Street (where the library had been) to Berkeley Street, running a block between Newbury to Boylston. It was the first building of an institutional nature in the Back Bay, but it would not be the last. The Massachusetts Institute of Technology moved next door the following year. (It later moved across the Massachusetts Avenue Bridge to Cambridge.)

These institutions and others flourished in the heady educational climate that Boston enjoyed then and still does. In 1852, Boston became the first city to make education compulsory. Schools and colleges had been established in and around the city during that time and later. Boston Latin School was the oldest public school in the country when it was set up on School Street. It later moved to the South End (Warren Avenue) and then to the Fenway.

Harvard, of course, had been in place since 1636. In fact, in a way, it had spawned Yale. The well-known minister Cotton Mather wanted to be president of Harvard, as his father, Increase Mather, had been, but he was passed over four times and became vengeful. The Mathers also disliked the way the school was getting away from orthodox Puritanism. Mather decided to form his own divinity school, which he called the Collegiate School of Connecticut. For financial support, he turned to Elihu Yale, a rich Welsh trader. Yale donated cotton bales that sold for £562, a large amount of

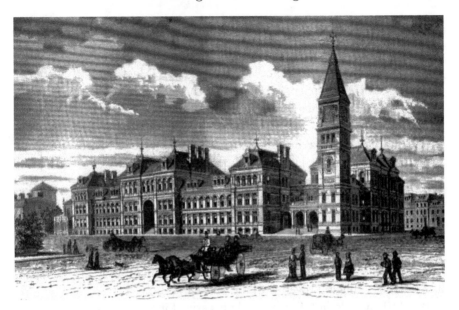

Boston Latin and English High Schools.

money in those days. He also donated forty-one books. In return, the school decided to locate in New Haven, Connecticut, and was called Yale.

But it would not be New Haven but the Boston area that would become the educational center of America. At the turn of the twenty-first century, about one-quarter of a million college students from all over the world would reside in Boston each semester. In addition to schools like Harvard, Tufts, Radcliffe and Wellesley on the perimeter of the city, many were established within the city, such as Boston College on Harrison Avenue in the South End in 1864. Boston University began on Boylston Street; its Commonwealth Avenue campus came many years later. Northeastern University, established in 1898 on Boylston Street, moved to Huntington Avenue in 1913.

The first medical school in the nation for women, Boston Female Medical School, along with colleges like Emmanuel and Simmons on the Fenway, catered to females only. Simmons was established by the will of John Simmons, who made a fortune in ready-to-wear men's clothes and then in real estate. He sympathized with the seamstresses who made the clothing and wanted to give women a way to use their brains to make their living. Simmons College was his answer starting in 1899.

Farther along the Riverway was Wheelock College, which taught young women to become teachers of young children, while in the other direction,

Wentworth Institute opened in 1911 to serve technical students and future engineers. Just a few blocks west on Longwood Avenue, schools and colleges such as the Massachusetts School of Art & Design, Massachusetts School of Pharmacy & Health Sciences, Harvard School of Public Health, Harvard School of Dental Medicine and Harvard Medical School were established.

Longwood Avenue also became a medical district and remains so today, with Children's Hospital Boston, Beth Israel and Deaconess Medical Center, Brigham and Women's Hospital, Dana Farber Cancer Institute and Joslin Diabetes Center.

Boston has long been one of the world's top medical areas, beginning in the seventeenth century with the first inoculation against smallpox in America. At Massachusetts General Hospital in 1846, Dr. William Morton first demonstrated the use of ether. The Ether Dome still exists at Bulfinch's Massachusetts General Hospital and is open to the public. Medical excellence in Boston has only improved with the passage of time.

By 1891, a wide link finally made it easier for traffic to travel from the South End to the Back Bay. West Chester Park had been, in that year, connected via the new Massachusetts Avenue Bridge to Cambridge, and the street was called Massachusetts Avenue on both sides. Now an important artery, it not only forged another Boston to Cambridge link over the longest bridge on the Charles River, but it also became an important cross street on the Boston side.

It connected Boylston Street and Huntington Avenue, and the Back Bay with the South End, by a quicker route than any other. By that time, the South End had been built and then built up. But it fell short of expectations. It did not become another Beacon Hill or Back Bay. For a while, it flared brightly as a promising residential area, but that was not fated to last.

While it seems reasonable that two adjacent residential areas like the Back Bay and the South End would have blended into each other, that didn't happen, mostly because the railroads kept them physically separate and there was no real coordination between the two districts. Their street grids ran at a forty-five-degree angle from each other because Back Bay streets ran parallel to the milldam (later Beacon Street), and those of the South End paralleled the Boston and Providence Railroad tracks. There was no easy way to join them together.

Eventual development of the area due south of Boston started when Boston Neck was widened in 1805, adding a street east of Washington that would later be called "Harrison Avenue" after William Henry Harrison. Street grids were laid out ten years later. In 1821, when Back Bay was being

Building the Golden Age

The Great Fire of
Boston, 1872.

dammed, some areas around the present Shawmut Avenue and Castle Street near Park Square were filled in, and a few years later it had four north–south streets (adding Tremont Street and Shawmut Avenue, then called Suffolk Street), as well as side streets.

Another 570 acres of land south and east of the Neck was added and called the New South End. The old South End ran from the Common to the waterfront and north to State Street, and most of it would be destroyed in the Great Fire of 1872, which started at Kingston and Summer Streets on November 9 and destroyed about 65 acres in two days, much of it in the financial and business district.

In the 1850s, with the city becoming crowded, the (New) South End was developing rapidly. The Catholic Church was represented in the 1860s by Boston College, the Jesuit Church of the Immaculate Conception next to it and the Cathedral of the Holy Cross at Washington and Waltham Streets. In 1864, Boston City Hospital was built between Albany and Harrison Avenues, its domed administration building designed by Gridley J.F. Bryant, son of the man who built the Granite Railway in Quincy.

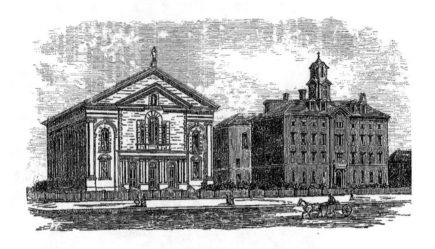

Boston College, South End.

The Girls' High School, with its mansard roof, appeared on West Newton Street in 1870, the largest school in the country at the time. Seven years later, it was displaced at the top by Boston Latin and English High Schools in a single building on Warren Avenue, then called the largest school building in the world.

The South End's main feature, though, was the blocks and blocks of housing. Much of it was built in Victorian style and made of brownstone or red brick. These were blocks of bow-front buildings with standard heights, standard widths, regular setbacks and occasional squares or parks shaped like crescents with fenced green areas.

At first, the wealthy moved in, looking for new housing; but they didn't stay long. This area was overdeveloped. Too many houses had been built too quickly, and sales couldn't keep up with development, so the prices fell. Middle-class people moved in, and the wealthy moved out to Beacon Hill or the Back Bay as space became available.

In his 1937 novel *The Late George Apley* (also a 1941 film), writer John P. Marquand's satire of Beacon Hill Brahmins has his main character write a story for his children about how his father had built their house on Beacon Street after originally purchasing a bow-front house in the South End.

You may have seen those houses in the South End, the mansions with dark walnut doors and beautiful woodwork. One morning...my father...came

Union Park Street.

out with us to the front steps. I could not have been more than seven at the time, but I remember the exclamation that he gave when he observed the brownstone steps of the house across the street.

"Thunderation," Father said, "there is a man in his shirt sleeves on those steps." The next day he sold his house for what he had paid for it and we moved to Beacon Street. Your grandfather had sensed the approach of change; a man in his shirt sleeves had told him that the days of the South End were numbered.

And numbered they were. With the Panic of 1873, single-family homes in the South End became apartments, and the area began to slide. Columbus Avenue, a major east–west boulevard that ran between Tremont Street and the railroad, a street that started in Park Square, had been extended as far west as Northampton Street, with developers putting up cheaper houses different in style than those on streets that had been established earlier. Banks foreclosed and resold, and the value dropped precipitously, affecting

real estate prices in the rest of the South End. The buildings were made into three- and four-family apartments, and by the end of the century, practically the entire South End was in this condition and settlement houses were trying to alleviate the slum conditions.

In the late 1900s, the Boston and Providence Railroad had a rail yard in the Back Bay between Boylston Street and Columbus Avenue and from Park Square west to Clarendon Street. But in 1900, South Station was built as a union station to serve both this railroad and the Boston and Albany, so that sixteen-acre rail yard adjacent to Park Square wasn't needed. During the first part of the 1900s, it was developed, mostly by insurance companies like John Hancock and Liberty Mutual. In 1962, the Prudential Center was built over the Boston and Albany tracks. The extension of the Massachusetts Turnpike was built parallel to the remaining tracks.

Things thus had come a long way since the nineteenth-century development of transportation, but it was in keeping with what had already been done. Boston had opened the century by building roads, railroads and canals, and it closed the century by improving its transit system. It remained a leader in this enterprise as well. The city moved more quickly than most major cities to alleviate its transportation problems, even anticipating some before they got a stranglehold. Boston still has an extensive subway system and surface lines of all types that help to keep some of its traffic off its narrow streets.

In the early nineteenth century, Boston had improved its roads, built new canals and had begun the construction of railways, linking it with outlying cities and towns. For labor, they went first, of course, to locals, but this was a limited force, and by the 1840s it had largely been depleted. Never a people to be stifled by tradition, these new Bostonians hired immigrants—Irish ones mainly, those who were coming to America to escape starvation from the plight of the blight of potatoes. These men worked for very low wages.

Boston manufacturers continued to make profits during the Civil War by their production of weapons, shoes, blankets and other materials for the troops. As we have seen, the city also sounded as a leading voice during the abolitionist movement. The industrialization that had begun in the early decades of the nineteenth century continued to the end of it—a time that became Boston's greatest industrial era, a time when it made a great variety of goods and offered many new services. As millions of immigrants from around the world came to America, many of them headed to Boston, where they first found jobs, then a home and later a voice in running things.

The city of Boston already had public transportation lines that were called "street railways" when they were pulled by horses starting in 1845.

Twenty-five years later, the lines stitched all over Boston and into the suburbs. Those towns that could be reached in this way were known as the "streetcar suburbs."

By the end of the century, electric lines that stretched overhead powered the cars. A metal trolley connected the car to its electrical source, and the cars became known as trolleys or streetcars. Within the downtown, the lines met at centers like Scollay Square, Bowdoin Square and Haymarket. The overhead wires became a spidery web of electrical connections, and the cars crept slowly through traffic beneath them. It was time for another Boston solution.

The city streets had become overcrowded. Boston faced severe traffic problems in its downtown area—the worst it had ever known. Trolleys and carriages, both pulled by horses, clogged the traffic arteries. One of the worst areas was along Tremont Street by the Boston Common. It could take the better part of a half hour to go just a mile. You could walk it in half the time.

A new traffic commission decided that subways would be the answer to the problem along Tremont Street. There were *no* subways in all of America

Tremont Street.

at the time. London's "tube" had become the world's first in 1863, and there were two others in Europe.

It was easy for the commission to say let's do it and another thing to get it done, for there was opposition to building a subway. Some called it a "monstrosity" that would destroy the beauty of the Boston Common. Fears of unearthing the remains of buried Revolutionary soldiers were also expressed. Owners of businesses were afraid they would lose customers if people were underground rather than walking along looking in their windows. People who owned buildings thought the foundations were apt to be weakened.

There were even fears of bad air and evil spirits underground. A local undertaker said, "I don't believe in a tunnel or a subway. I expect to be a long time underground after I am dead, but while I live I want to travel *on* earth, not *under* it."

It was left up to the people. They voted. When all the votes were counted, those who wanted a new subway won by a narrow margin: 15,483 to 14,212. Even at that it wasn't clear-cut. The city had to promise mitigations to abutters and to the public, including a promise to restore the Public Garden according to a plan by Olmsted, whose work had already gained favor with his parklands.

So in 1895, the digging began along Tremont Street. A trench was dug, supports were raised and covered and then the earth was put back. Then walls, floors and ceilings were put in place and stations and lighting were put in. Track was laid. It wasn't easy. It was messy. At first, it made traffic worse. And those who had thought it would be dangerous were right, too. Nine workers were killed and many more injured during the digging by a gas explosion at the corner of Tremont and Boylston Streets. It struck terror into the minds of the laborers.

But on September 1, 1897, America's first subway made its first run in the tunnel between Park Street and the entrance to the Public Garden. The *Boston Globe*, in reporting the opening, contributed phrases for posterity: "Before the readers of *The Globe*, or at least the majority of them, open their morning's paper today, the hum of the electrics will have turned the underground railway into a scene of human activity wholly new to the busy life of Boston."

It went on to sensationalize the sensation of traveling underground: "whirling along at a rate of speed which they have never experienced in the same locality before, and projected out of the earth at the Park Street exit of the subway."

Park Street subway station.

The unctuous *New York Times* also reported the event, surprisingly placing it into the category of "All the News That's Fit to Print" but downgrading it by Pecksniffian comments about how remarkable it was that conservative Boston should be the pioneer in something like this.

But the effects were beneficial. The subway smoothly carried passengers on a regular schedule, whereas previously a similar number had bumped along above ground at the rate of two hundred trolleys an hour in each direction. It was such a good idea that it certainly had to be extended.

Next came an elevated railway that ran from Roxbury to Boston and over a new bridge to Charlestown. The bridge was the longest in the United States at that time. An elevated railway was cheaper than a subway but far more noisy and ugly. It was the only one built in Boston and was later torn down.

Next would come a tunnel for subway trains under Boston Harbor to East Boston. This would be dangerous to build. New York had tried twice to dig tunnels like these but had failed. Boston succeeded, and the tunnel was then connected to the existing subways.

The fourth part of the subway system would be a tunnel from Harvard Square in Cambridge to Andrew Square in South Boston. This also required digging a tunnel by boring under Beacon Hill near the State House. It took nine years and was completed by 1918.

All this may have been too much too soon for old Boston, as the *New York Times* had implied. A story was told by Lynda Morgenroth in *Boston Firsts* about a deliveryman who left his horse and wagon unhitched as he made a final quick delivery to a building. When he returned to go home, he found them gone. The horse had decided to take off and, reaching the Kenmore Square area, followed the road as it dipped down into the subway and went click-clacking along the tracks. An alert was given to the next station—Massachusetts Avenue—where patrons were greeted by the eerie sight of a horse and wagon clattering out of the darkness into the light of the station. Transit agents were able to corral the horse and return it to its befuddled owner, giving him back his nineteenth-century means of transport that may have seen the future earlier than he had.

The subway stations of those original lines are still in use, and 95 percent of the tunnels are still used. They are now called the Red, Orange, Green and Blue lines. The Red line honors Harvard University, whose official color is crimson, and which has a stop on the line. Orange was the original name of much of Washington Street, the path along which much of it runs. (A good part of the line now follows the rail route of the Boston and Providence Railroad.) The Green line passes through parts of the Emerald Necklace park system, and the Blue line runs beneath the water to East Boston and Revere. All of them have been extended in the twentieth century and beyond, and light rail lines have been added and named the Purple line. The system also includes water transportation.

EPILOGUE

The post-Revolutionary period and nineteenth century saw a changing of attitudes and habits among upper-class Bostonians that led to such trends as a change from international trade to industry, evolving outlooks on the question of slavery, a flowering of cultural pursuits and building of the land and infrastructure that led to the Boston we have today.

Growth of the city continued into the final decades of the nineteenth century, with a short setback from the Great Fire of 1872. The city's population grew mostly from immigration but also from accessioning neighboring towns such as Roxbury, Dorchester, West Roxbury, Brighton, Charlestown, East Boston, South Boston and Hyde Park. With those additions plus the filling in of land, the city grew to about thirty times its original size. Transportation grew as well. In the nineteenth century, that meant primarily railroads but also an expanded public transit system. That allowed people, including businesspeople, to live in the suburbs and commute.

Even with this growth, Boston remained a small city geographically compared with other cities of similar significance. The major buildings and institutions we've mentioned are within walking distance or at most a quick commute on public transit. Those institutions and most of the city's historical places have held up well over the years. Some other things have not.

Boston was a leading national city in the eighteenth and early nineteenth centuries, attaining the position as the nation's fourth-largest industrial center by 1880. Investment and banking had also become a big part of the city's commerce. This, of course, marked the beginning of the Gilded Age in America. Boston, with its Puritan background and general simplicity of

Boston, 1880, map of built-upon land.

design, didn't go overboard in that direction, though it did use its profits in cultural endeavors.

But as the United States expanded westward, Boston's position in commerce and the nation's life was diminished. In the first half of the twentieth century, Boston went into a period of decline, but its leaders showed the wisdom to reinvest at the right time, and the city revived starting with the building of the Prudential Center. The final decades of the twentieth century can be viewed as its "Second Golden Age." But that's a subject for another book.

BIBLIOGRAPHY

BOOKS

Allison, Robert J. *A Short History of Boston*. Beverly, MA: Commonwealth Editions, 2004.

Bacon, Edwin M. *Rambles Around Old Boston*. Boston: Little, Brown and Co., 1921.

"Boston Looks Seaward: The Story of the Port, 1630–1940." Sponsored by the Boston Port Authority, Boston, Bruce Humphries, Inc., 1941.

Boston Public Library. "A Framework for Discussion: Huntington Avenue/ Prudential Draft Plan." Memo from Rita Caviglia, W. Todd Estey to Eric Schein, October 13, 1989.

Crocker, Matthew H. *The Magic of the Many*. Amherst: University of Massachusetts Press, 1999.

Cromwell, Adelaide M. *The Other Brahmins: Boston's Upper Class 1750–1950*. Fayetteville: University of Arkansas Press, 1994.

Dublin, Thomas. *Lowell: The Story of an Industrial City*. Washington, D.C.: U.S. Department of the Interior, 1992.

Greenridge, Kerri. *Boston's Abolitionists*. Beverly, MA: Commonwealth Editions, 2006.

Howard, Brett. *Boston: A Social History*. New York: Hawthorn Books, 1976.

Li-Marcus, Moying. *Beacon Hill: The Life and Times of a Neighborhood*. Boston: Northeastern University Press, 2002.

Mitchell, Thomas R. *Hawthorne's Fuller Mystery*. Amherst: University of Massachusetts Press, 1998.

Morgenroth, Lynda. *Boston Firsts*. Boston: Beacon Press, 2006.

Newman, William, and Wilfred Holton. *Boston's Back Bay*. Boston: Northeastern University Press, 2006.

O'Conner, Thomas H. *The Athens of America: Boston 1825–1845*. Boston: University of Massachusetts Press, 2006.

———. *The Hub: Boston Past and Present*. Boston: Northeastern University Press, 2002.

Petronella, Mary Melvin. *Victorian Boston Today: Twelve Walking Tours*. Boston: Northeastern University Press, 2004.

Schorow, Stephanie. *Boston on Fire*. Beverly, MA: Commonwealth Editions, 2003.

Scudder, Horace E. *Boston Town*. Boston: Houghton, Mifflin and Co., 1888.

Warner, Sam Bass, Jr. *Streetcar Suburbs: The Process of Growth in Boston (1870–1900)*. Cambridge, MA: Harvard University Press, 1962.

Wright, Conrad Edick, and Katheryn P. Viens. *Entrepreneurs: The Boston Business Community 1700–1850*. Boston: Massachusetts Historical Society, 1997.

Zaitzevsky, Cynthia. *Frederick Law Olmsted and the Boston Park System*. Cambridge, MA: Belknap Press of Harvard University Press, 1982.

ELECTRONIC SOURCES

"Boston Combusts: The Fugitive Slave Case of Anthony Burns." www.historynet.com/boston-combusts-the-fugitive-slave-case-of-anthony-burns.htm.

"The Concord and Lexington Minuteman Statues." *Concord Magazine*, September 1998. www.concordma.com/magazine/sept98/minman.html.

INDEX

ABOUT THE AUTHOR

Ted Clarke's passion is history, especially Boston history and that of areas around Boston. He is currently working on his twelfth book, most of which are on local history or figure skating, in which he was a judge and national administrator.

After years of teaching and journalism and three master's degrees, Clarke is "somewhat" retired but still spends a solid part of each day at his writing vocation. "I feel as though I've never retired, and yet I'm doing something I love to do," he says. "I've always enjoyed using words and telling stories, and here I do both. If you read my writing, I want you to get the story clearly but also enjoy the way it's told."

He has a forthcoming book from The History Press called *South of Boston*, part of a brace of books called "From Cape to Cape," which is in the works.

He and his wife, Mary, live in the town of Weymouth—south of Boston— where he serves as chair of the historical commission. He has written and narrated five television productions on town history, winning, in 2010, the Massachusetts Historic Commission's award for his program on historic preservation. He also gives frequent talks, which may be arranged through The History Press.

Visit us at
www.historypress.net

Printed in the USA
CPSIA information can be obtained
at www.ICGtesting.com
LVHW051823041123
762792LV00031B/3